QUEENSLAND

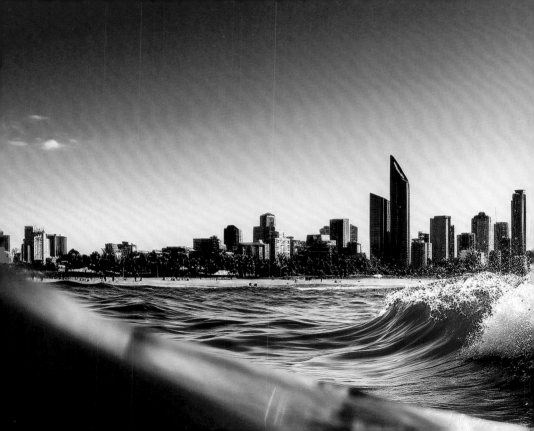

# QUEENSLAND
## THE SUNSHINE STATE

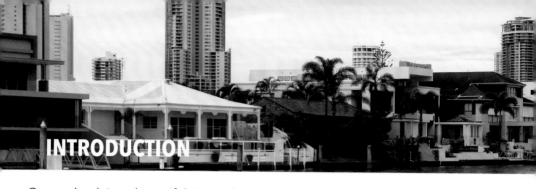

# INTRODUCTION

Queensland is a beautiful Australian state located in the northeast of the country, with a coastline spanning almost 7,000 km. It is home to the Great Barrier Reef, the world's largest coral reef systems, and one of the Wonders of the World.

When people think of Queensland they often imagine its stunning coastal scenery with the neon lights of the Gold Coast and the breathtaking Great Barrier Reef. However, this state has so much more to offer, including its rugged outback landscapes and ancient rainforests, which are rich in exotic wildlife.

Home to more than 1,000 ecosystem types and five World Heritage-listed sites, including the Scenic Rim National Parks, K'gari (formerly Fraser Island) – the biggest sand island in the world, Riversleigh fossil fields, and the Wet Tropics (including Daintree National Park).

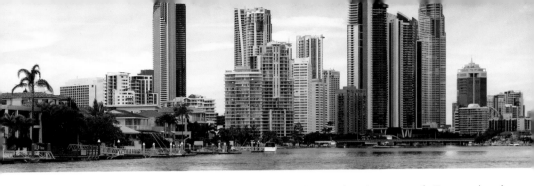

There's something altogether magical about the beauty of Queensland. With islands of white sand, the aqua waters in the Whitsundays, colourful coral bursts to life with fish and turtles on the Great Barrier Reef, and lush green canopies dance in the sun in the Daintree Rainforest.

It's not just the natural beauty that makes Queensland a great place to live. It is also a haven for adventure seekers, with opportunities for hiking, boating, surfing, kayaking, with its warm and sunny climate, you can enjoy these activities year-round.

It also offers a thriving arts and culture scene. From world-class museums and galleries to lively music and theatre venues, there's always something happening in this vibrant state.

Also in Queensland is the Australian outback which is a stunning yet

unpredictable landscape that presents a unique and unforgettable experience. From the flat Mitchell Grass Downs to the sand hills that merge seamlessly, and the gorges that create oases in an otherwise deserted land – it is a sight to behold. As you journey through small towns and cattle stations larger than some cities, you will be captivated by the changing scenery.

In 1928, Charles Kingsford-Smith, an aviation pioneer from Brisbane, and his colleagues made history with the first-ever air crossing of the Pacific, flying all the way from San Francisco to Brisbane.

In 1920 Qantas came into existence, originally founded in Longreach, Queensland.

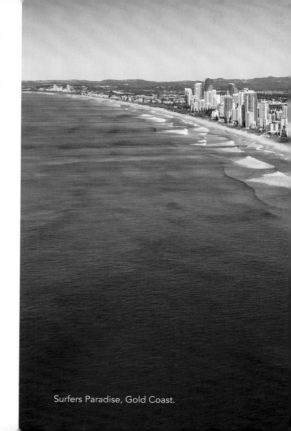

Surfers Paradise, Gold Coast.

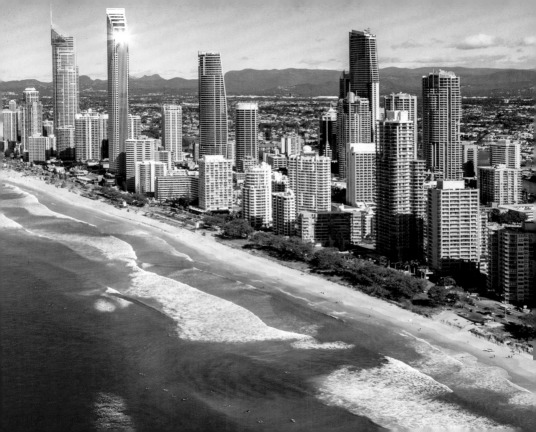

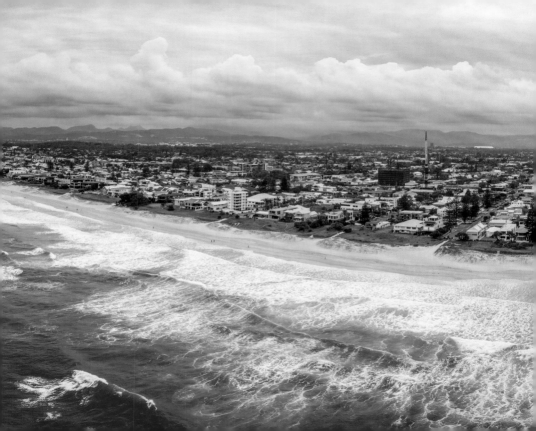

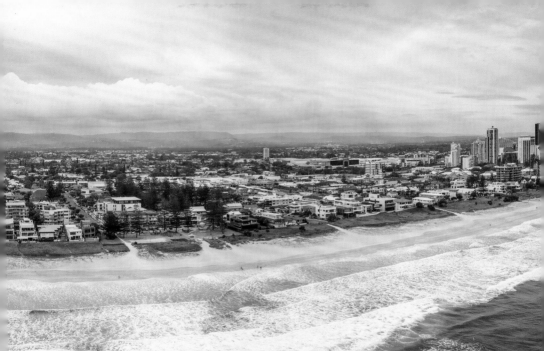

GOLD COAST

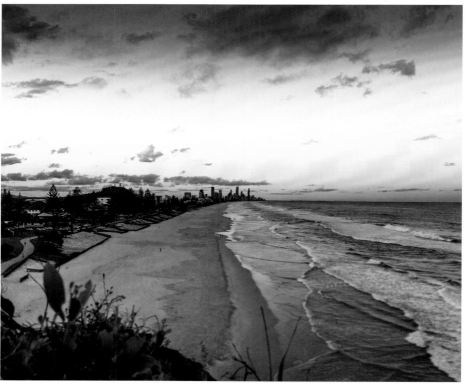

Sunset over Surfers Paradise on the Gold Coast.

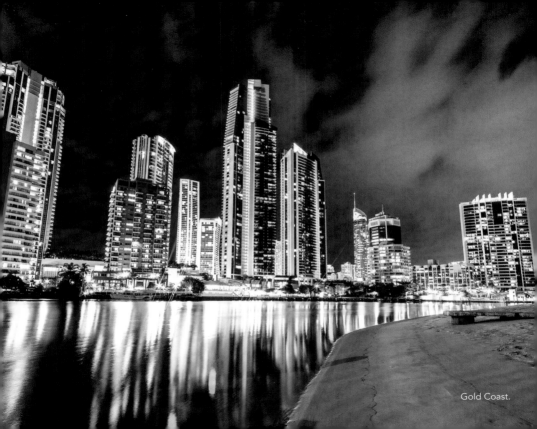

Gold Coast.

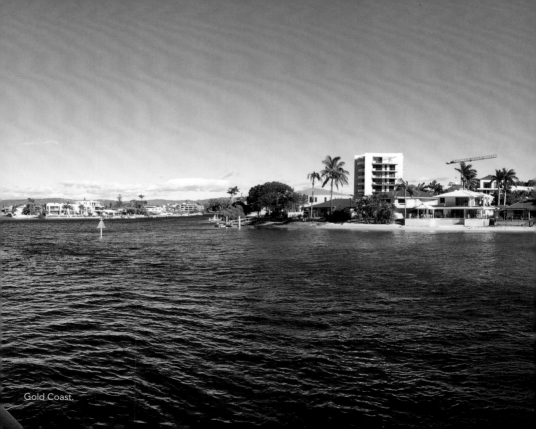

Gold Coast.

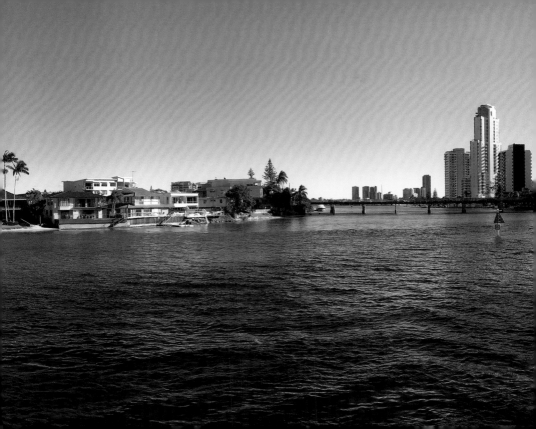

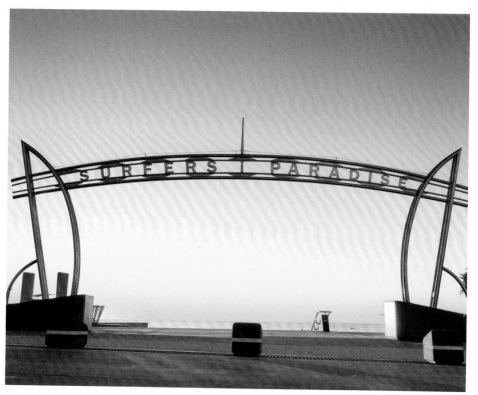

Surfers Paradise.

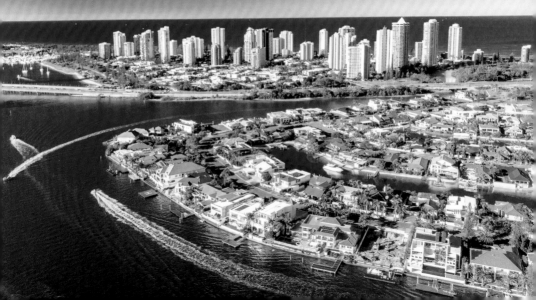

Surfers Paradise and Southport.

Gold Coast from SkyPoint Observation Deck.

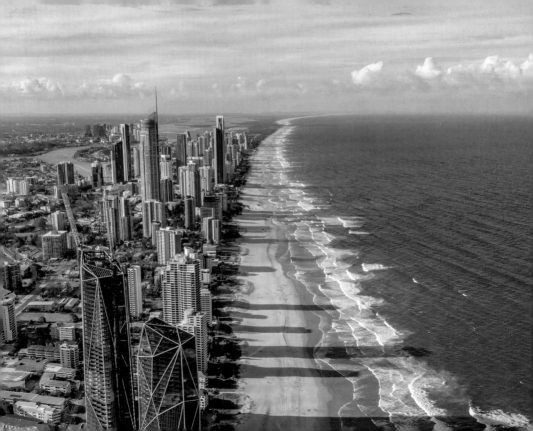

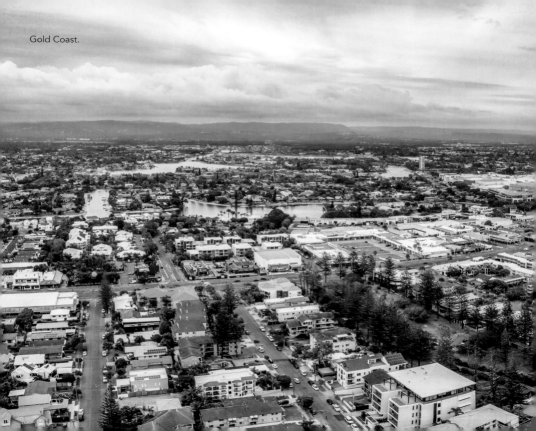
Gold Coast.

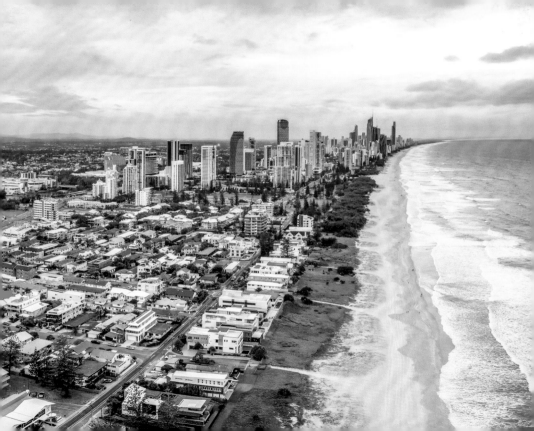

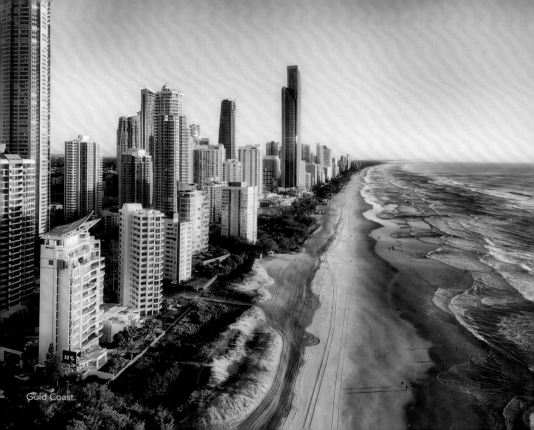

Gold Coast.

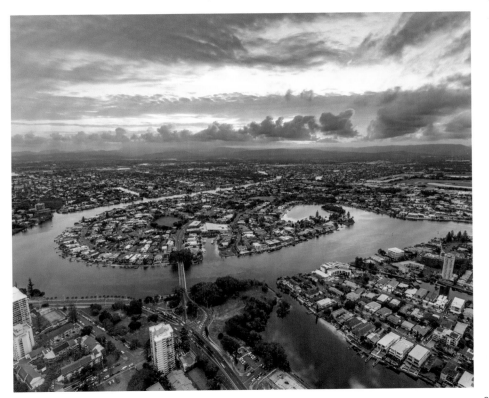

Gold Coast residential area and Nerang River.

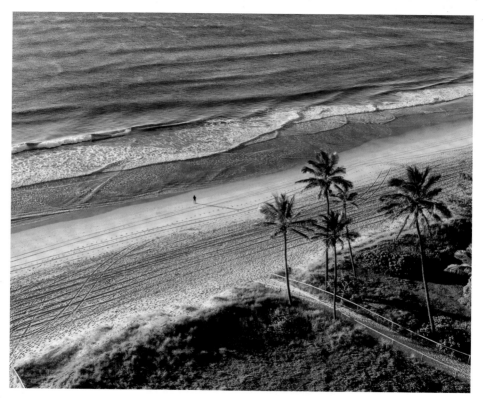

Gold Coast main beach.

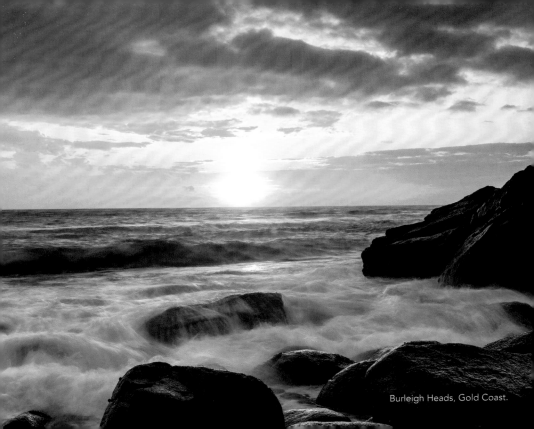
Burleigh Heads, Gold Coast.

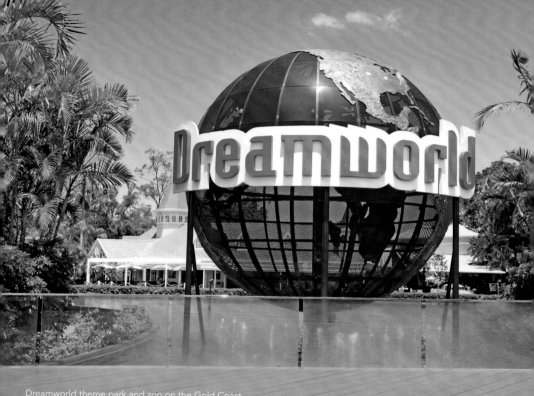

Dreamworld theme park and zoo on the Gold Coast.

Dreamworld theme park

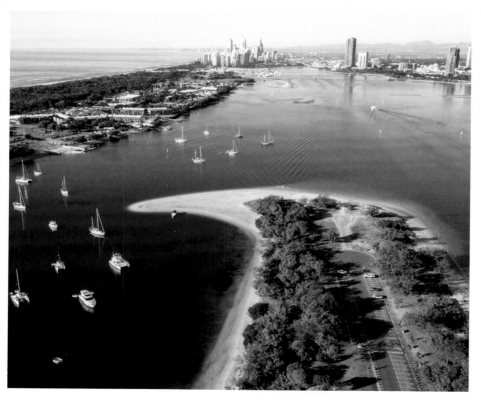

Doug Jennings Park and Broadwater.

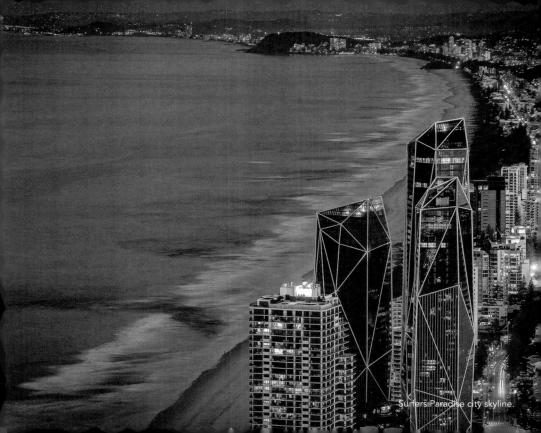

Surfers Paradise city skyline.

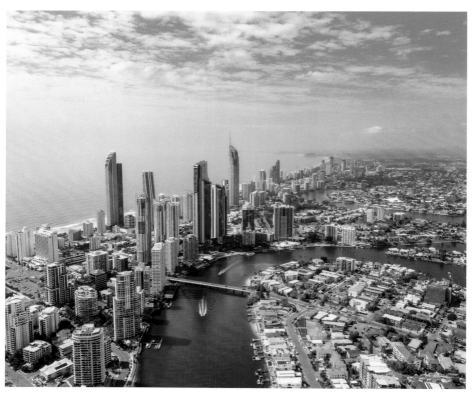

Gold Coast cityscape.

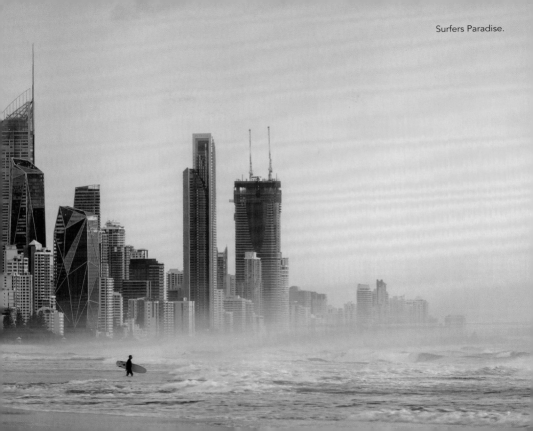

Surfers Paradise.

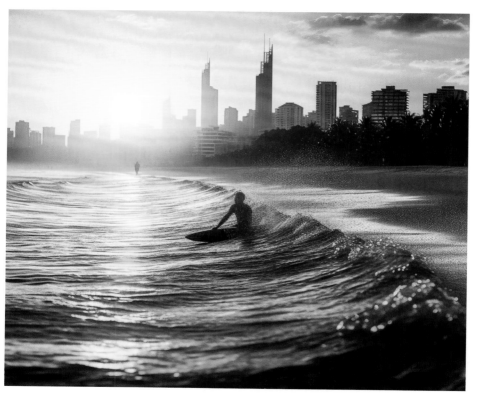

Burleigh Heads.

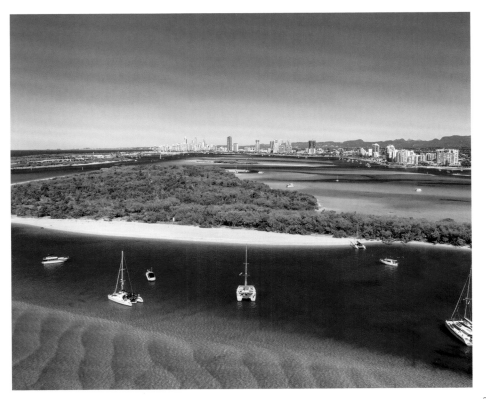

Boats around the Spit and the Gold Coast seaway.

Broadwater, Gold Coast.

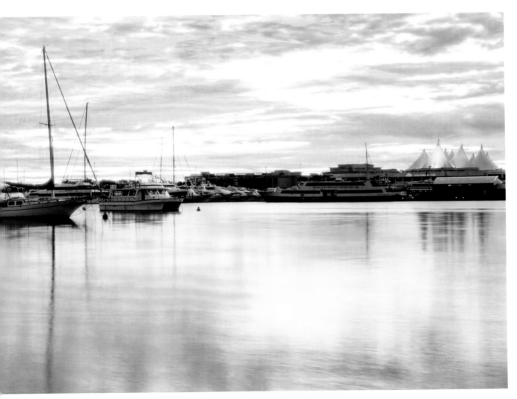

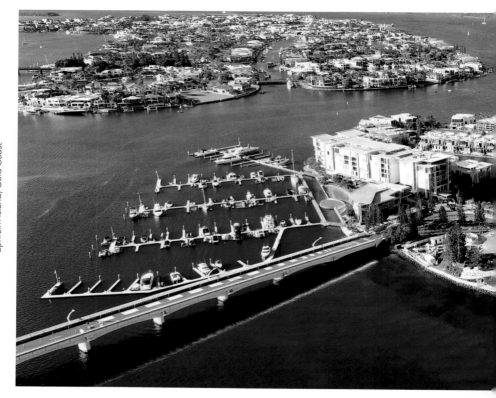

Ephraim Island, Gold Coast

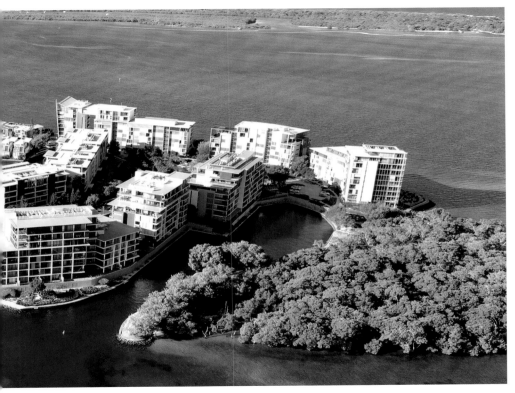

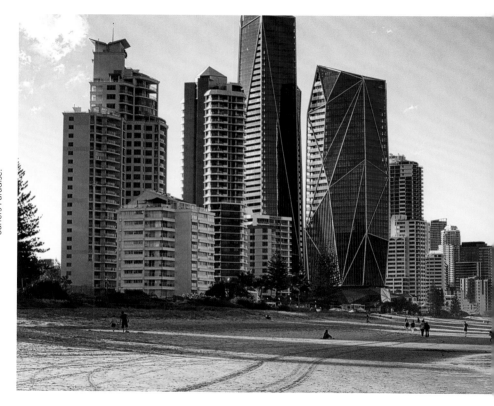

Surfers Paradise.

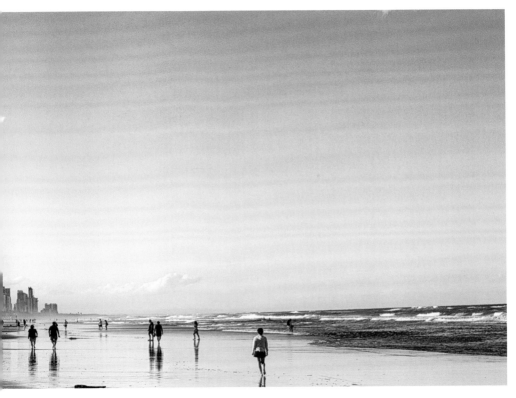

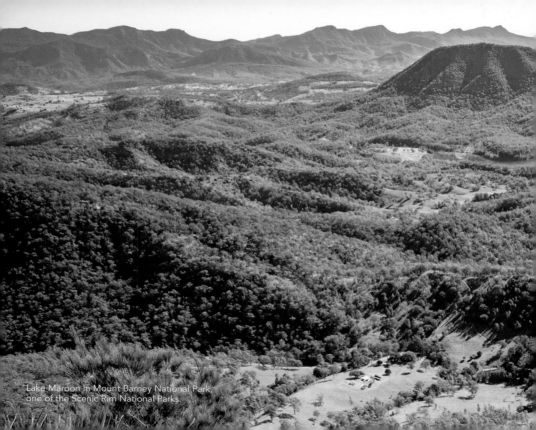
Lake Maroon in Mount Barney National Park,
one of the Scenic Rim National Parks.

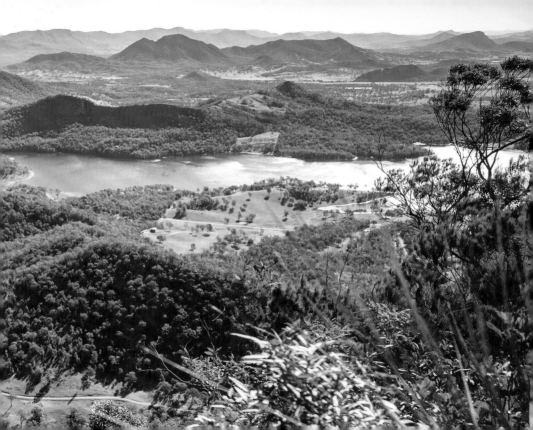

Lake Moogerah from the top of Mount Graville in Moogerah Peaks National Park.

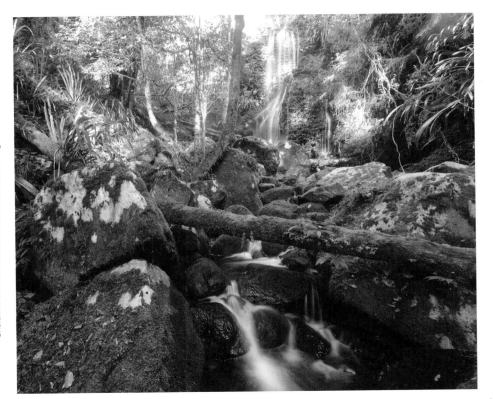

Chalahn Falls on Toolona Creek Circuit in Lamington National Park.

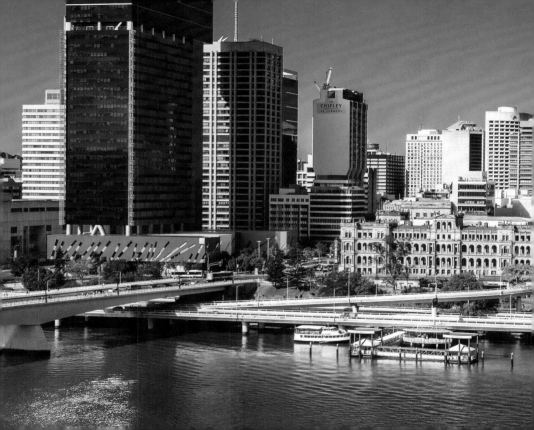

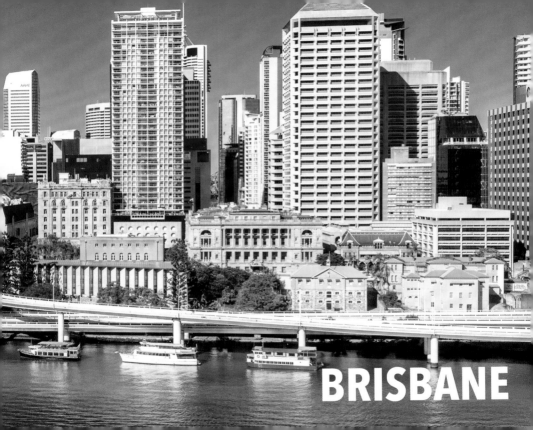
BRISBANE

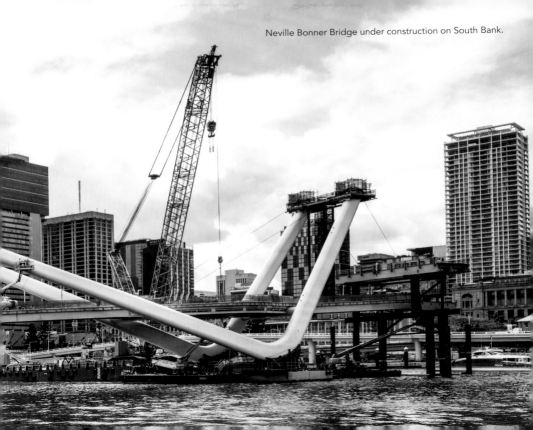

Neville Bonner Bridge under construction on South Bank.

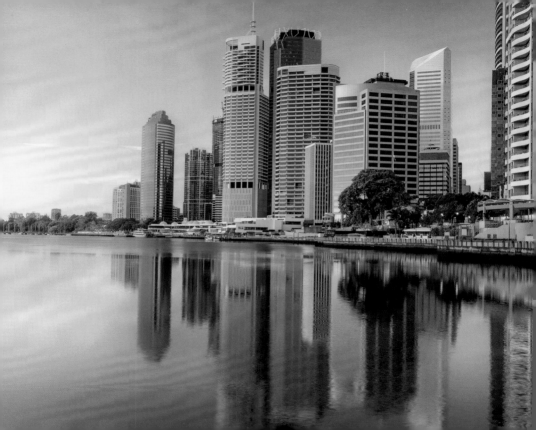

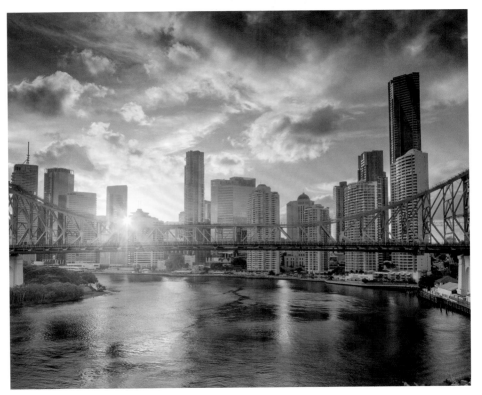

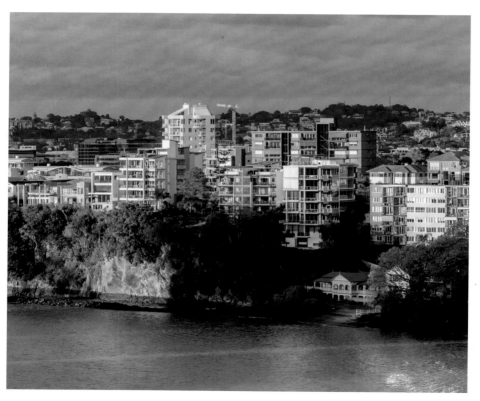

Riverside apartments, Brisbane.

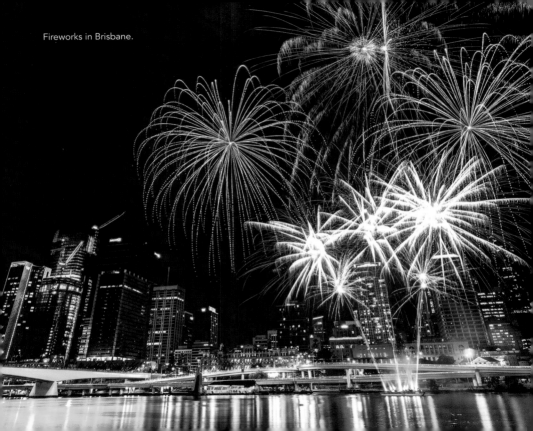
Fireworks in Brisbane.

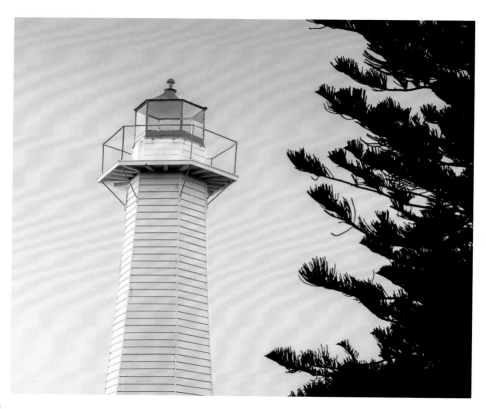

Cleveland Point Light.

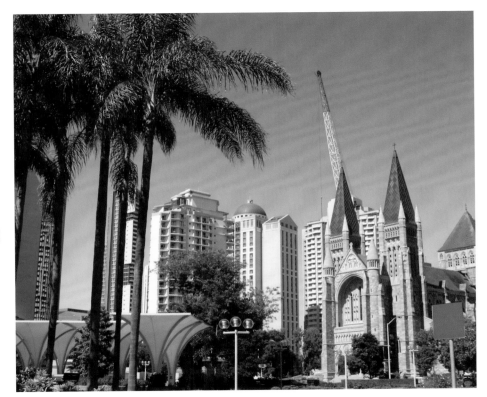

St John's Cathedral.

51

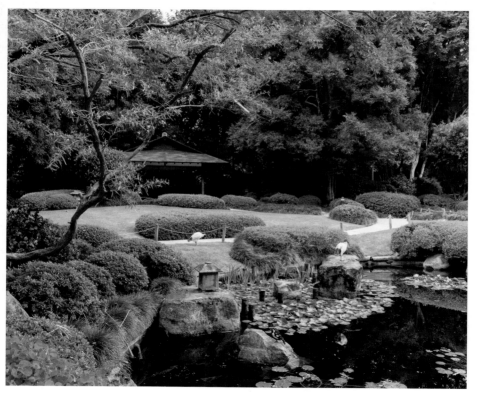

Japanese Garden, Brisbane Botanic Gardens Mt Coot-tha.

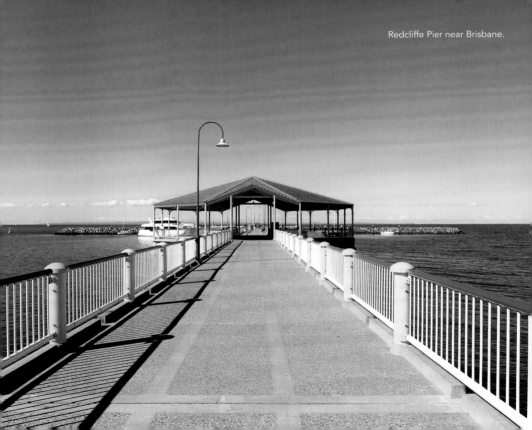

Redcliffe Pier near Brisbane.

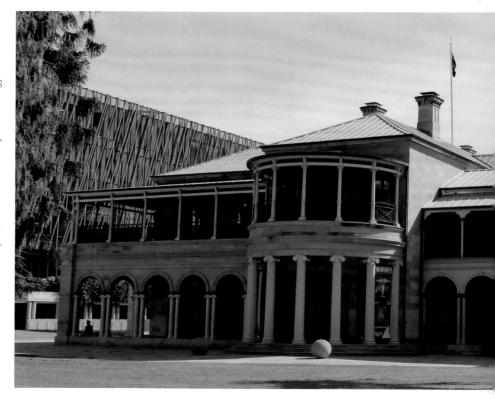

Gardens Point campus, Queensland University of Technology.

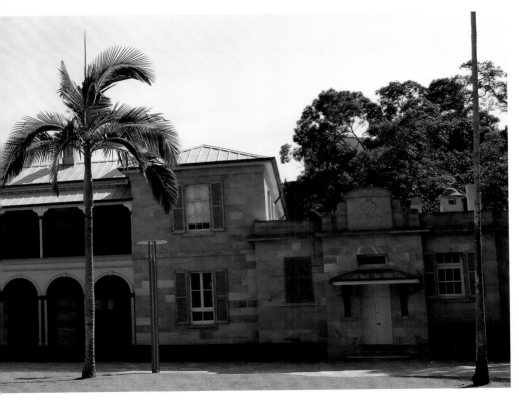

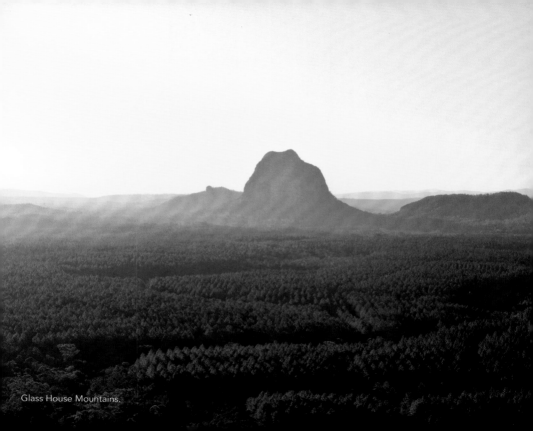
Glass House Mountains.

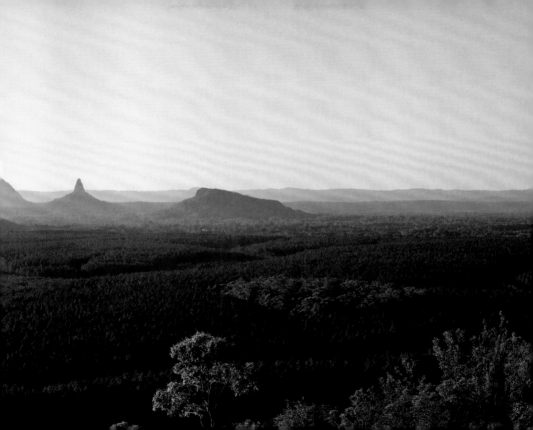

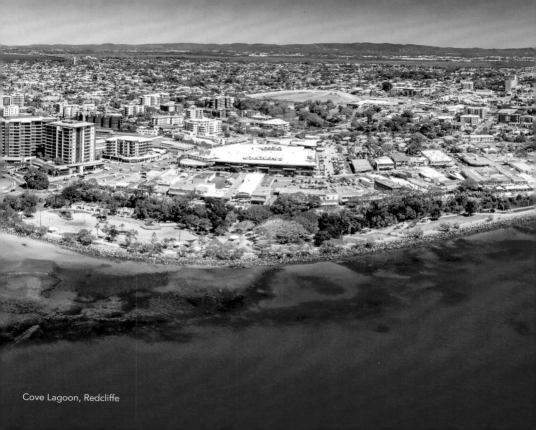

Cove Lagoon, Redcliffe

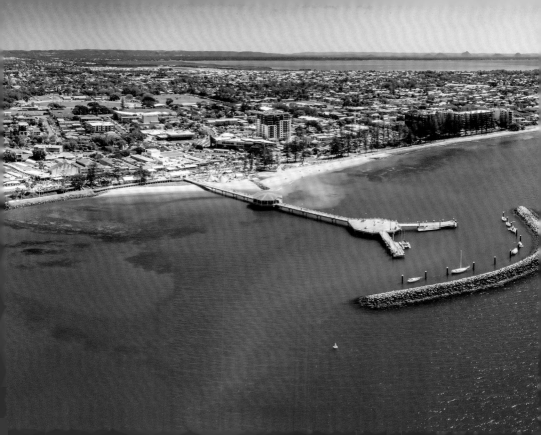

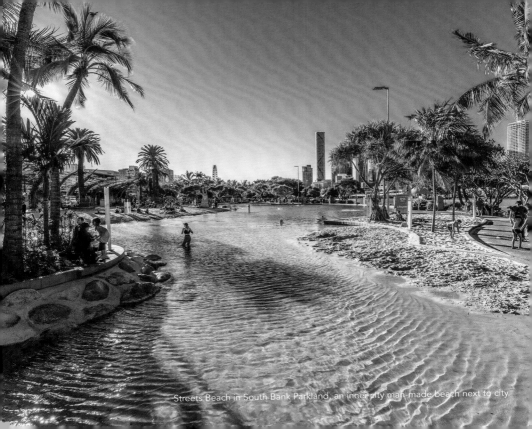
Streets Beach in South Bank Parkland, an inner-city man-made beach next to city.

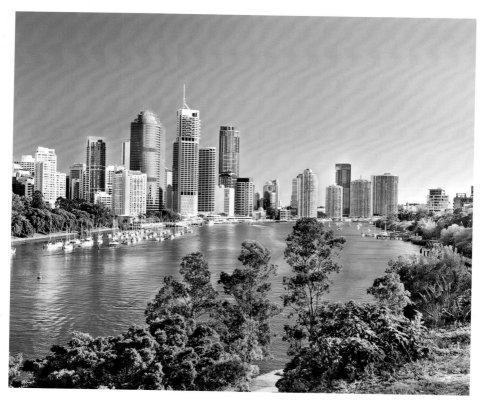

Blue water river.

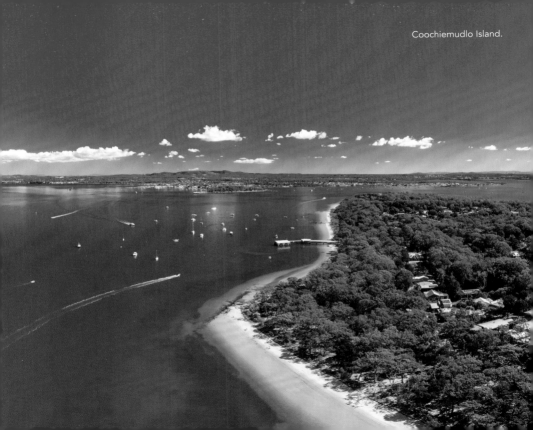
Coochiemudlo Island.

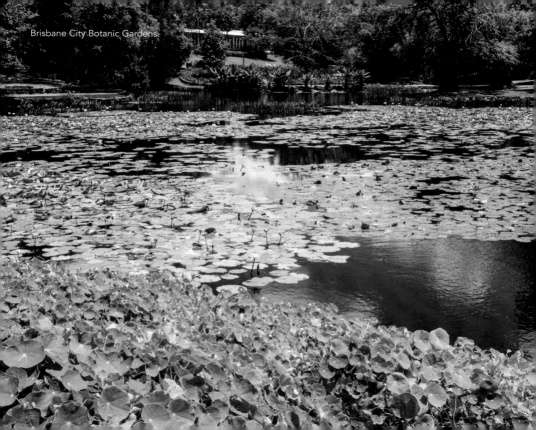
Brisbane City Botanic Gardens.

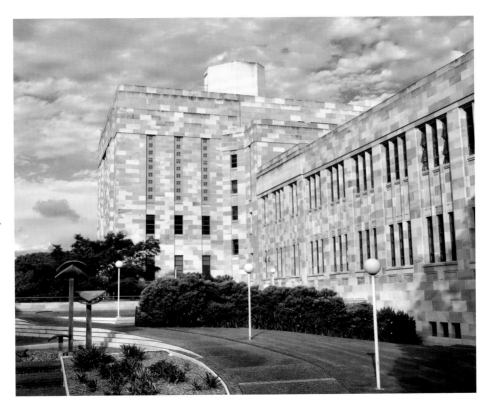

Brisbane city.

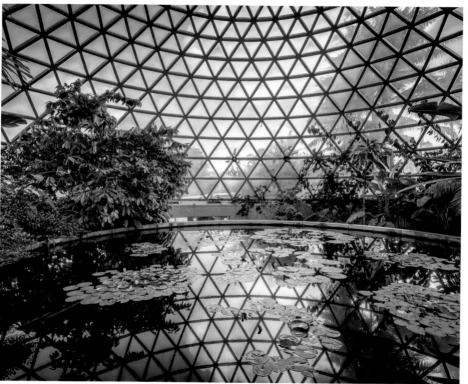

Display Dome inside the Brisbane Botanic Gardens.

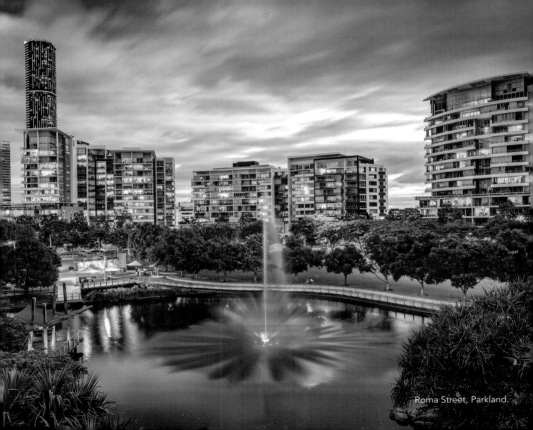

Roma Street, Parkland.

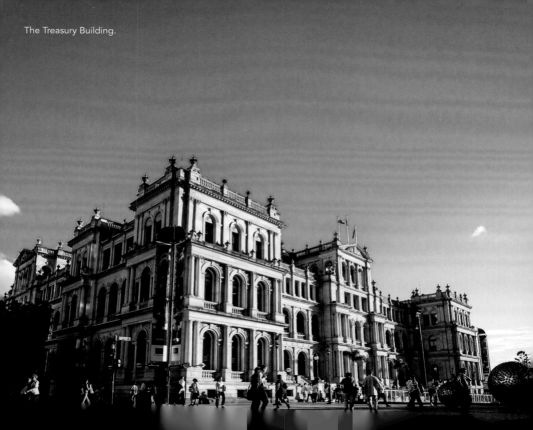
The Treasury Building.

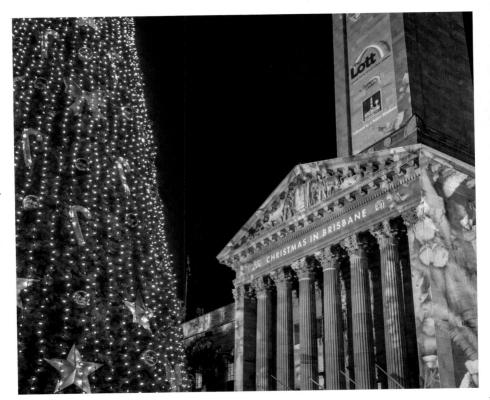

Brisbane City Hall.

Roma Street, Parkland.

74

Roma Street, Parkland.

Summit Lookout, Mount Coot-Tha.

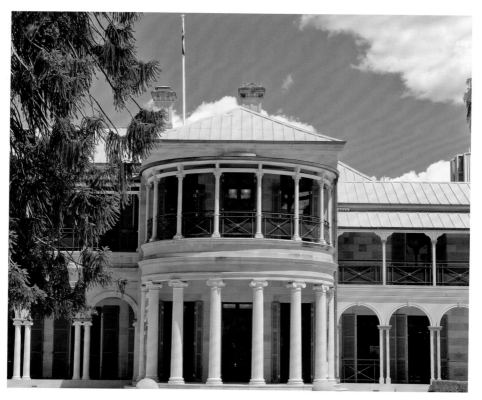

Old Government House.

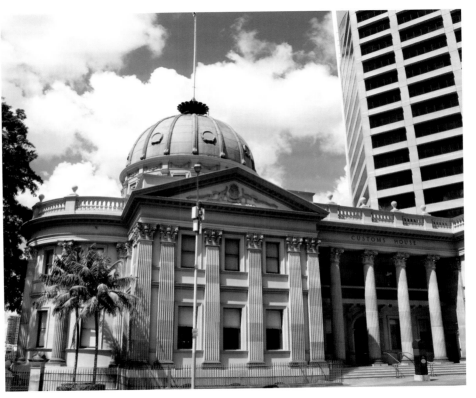

Customs House.

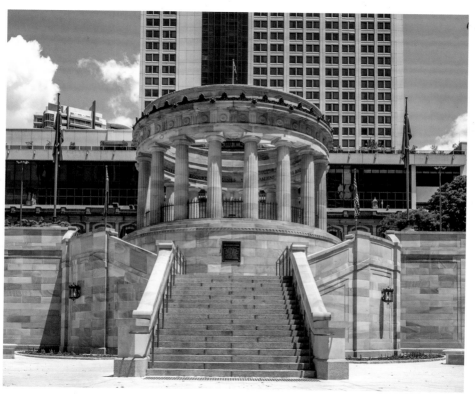

Anzac Square, Central Station.

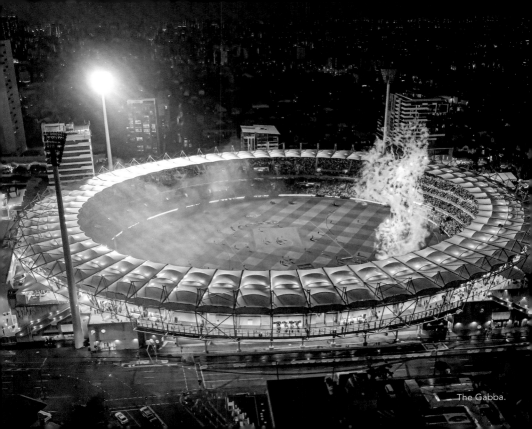

The Gabba.

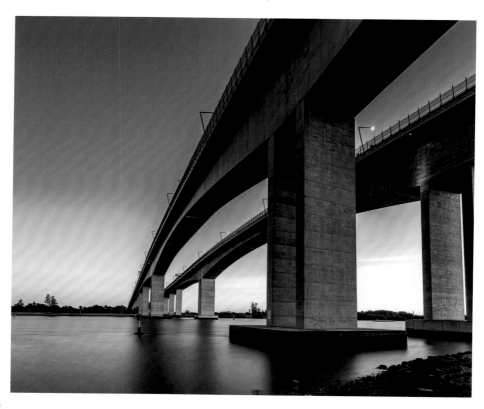

Gateway Bridge.

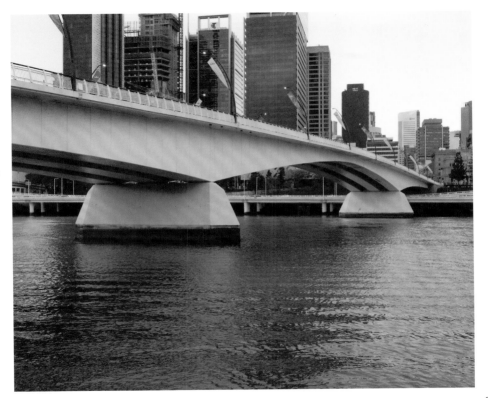

Go Between Bridge.

The Workshops Rail Museum is a heritage-listed former railway workshop in North Ipswich.

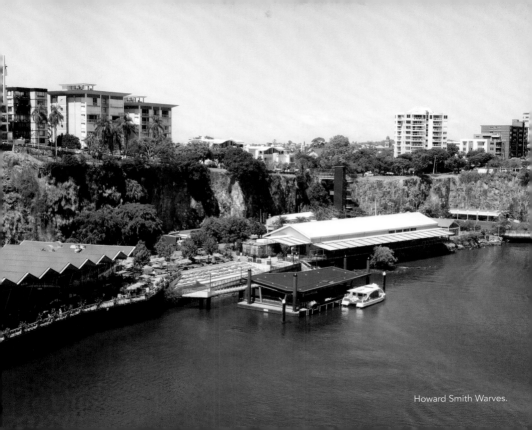

Howard Smith Warves.

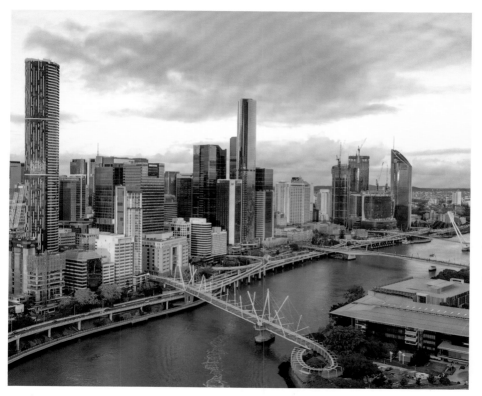

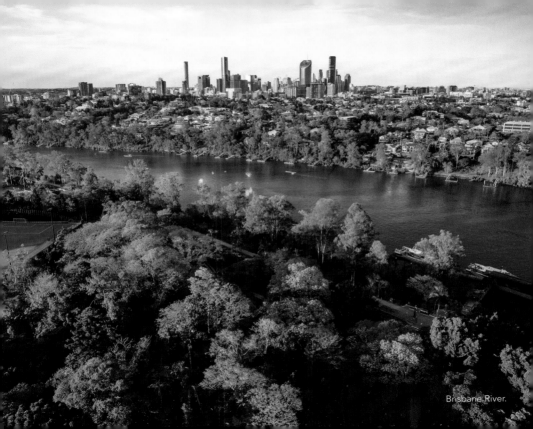
Brisbane. River.

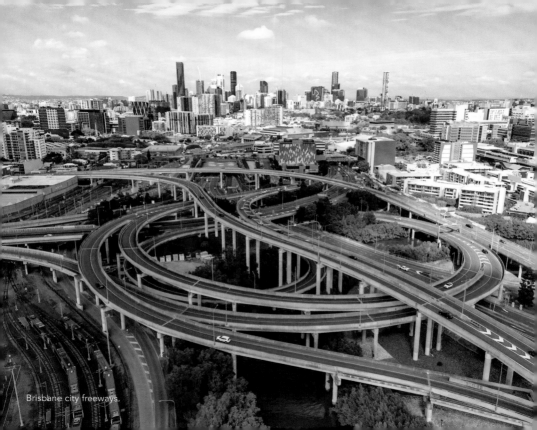
Brisbane city freeways.

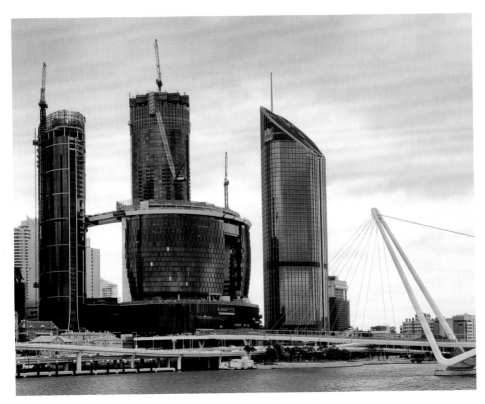

Queen's Wharf Brisbane.

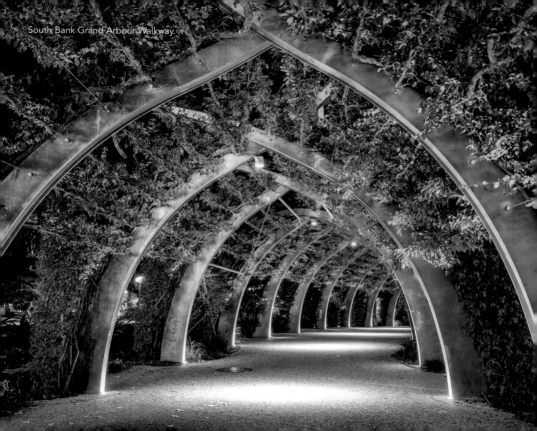
South Bank Grand Arbour Walkway.

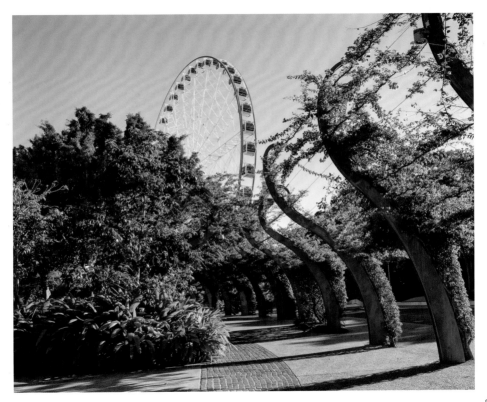

The Wheel of Brisbane.

New Farm River Walk along the banks of Brisbane River.

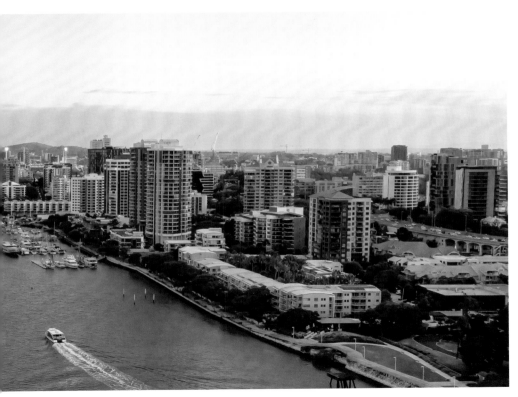

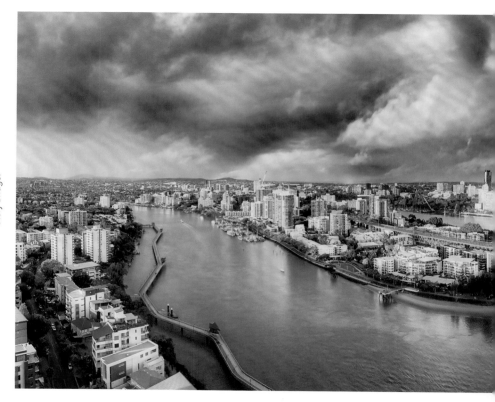

Story Bridge.

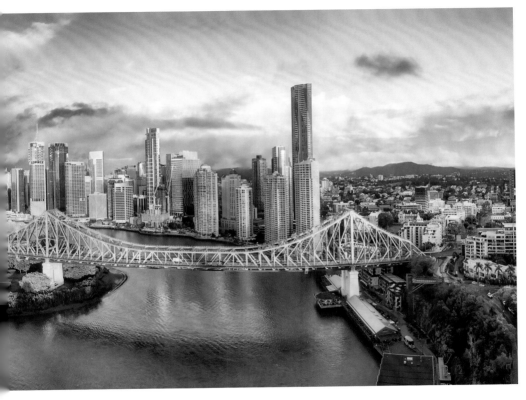

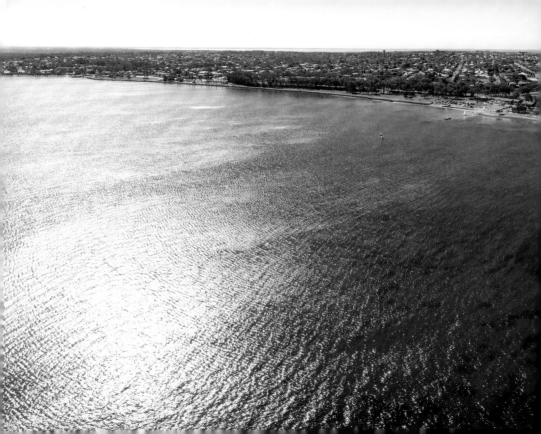

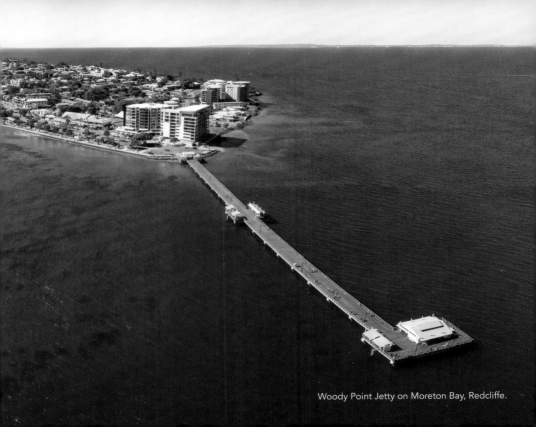

Woody Point Jetty on Moreton Bay, Redcliffe.

Queensland Art Gallery.

Queensland Museum.

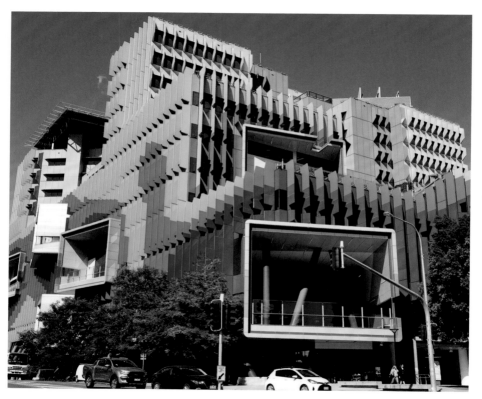

Mater Hospital Brisbane.

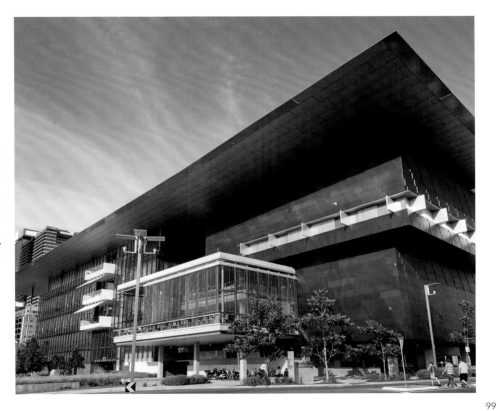

Gallery of Modern Art (GOMA).

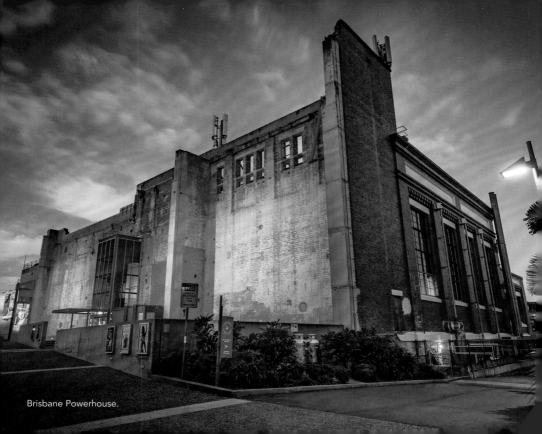

Brisbane Powerhouse.

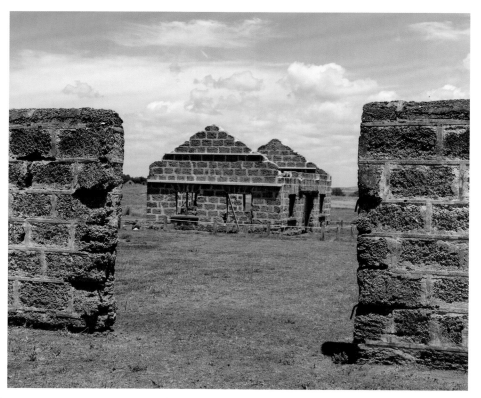

St Helena Island National Park prison ruins.

Tipplers Licensed Café, South Stradbroke Island.

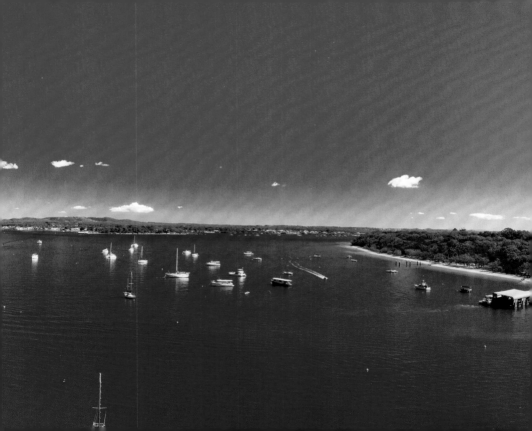

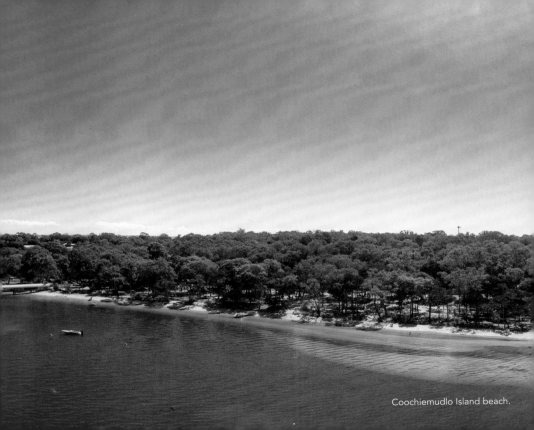

Coochiemudlo Island beach.

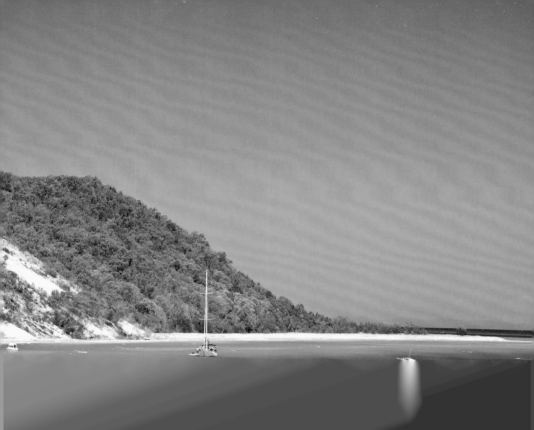

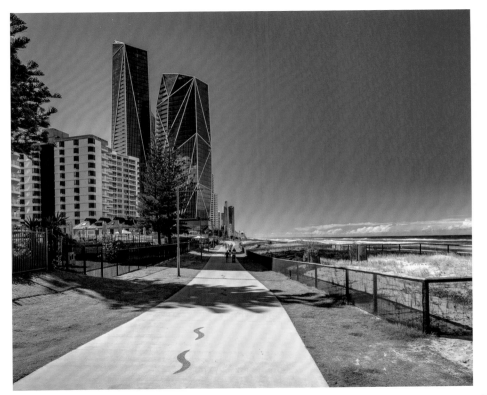

Footpath along the beach from Broadbeach to Surfers Paradise.

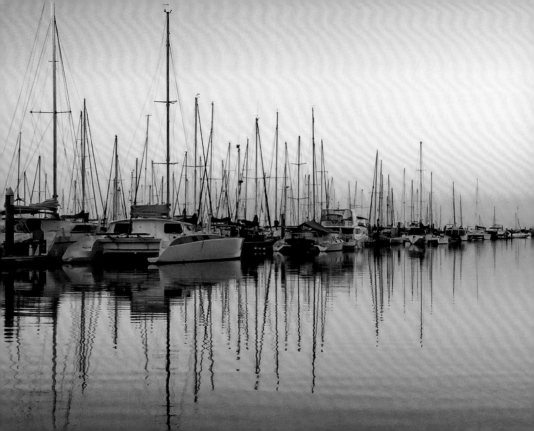

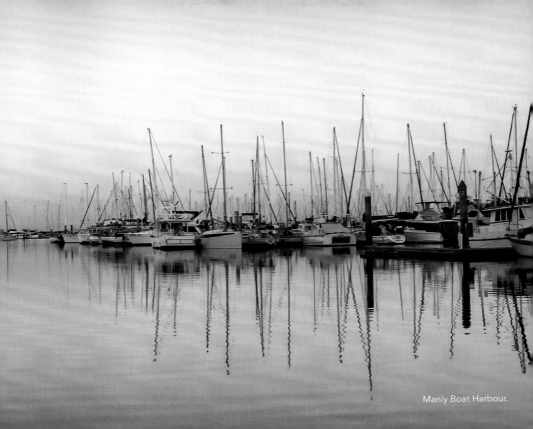

Manly Boat Harbour.

Moreton Bay.

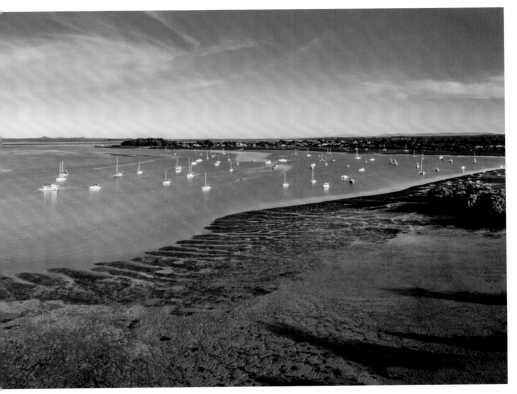

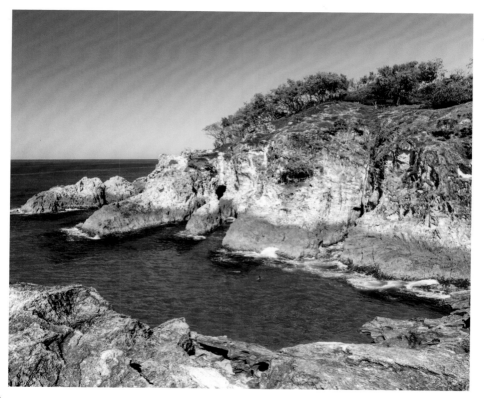

North Stradbroke Island.

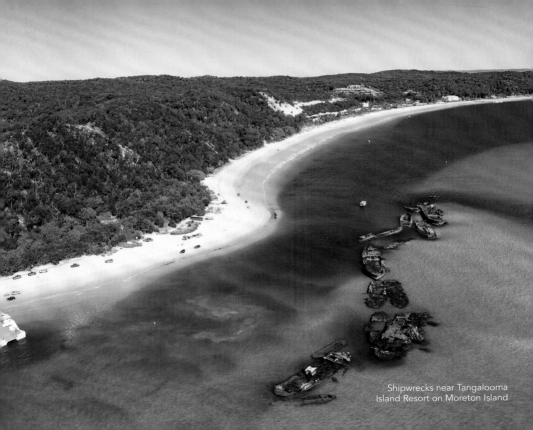

Shipwrecks near Tangalooma
Island Resort on Moreton Island

Bribie Island.

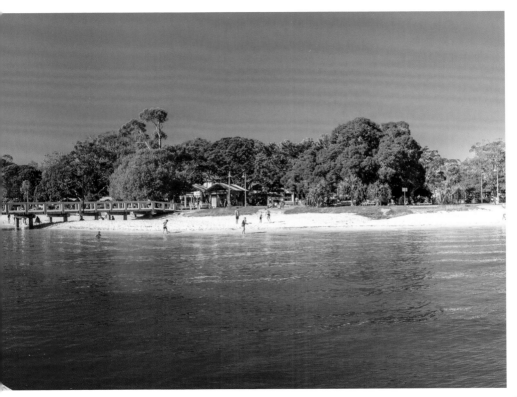

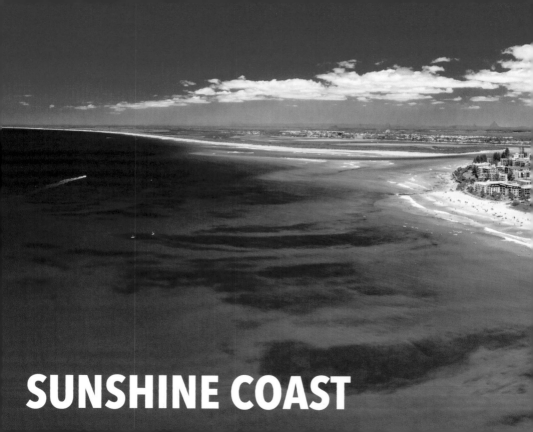

# SUNSHINE COAST

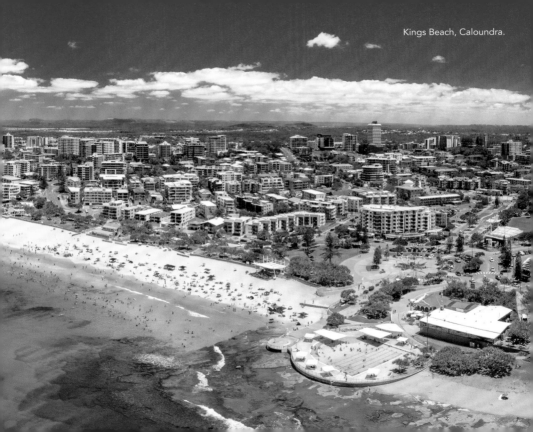

Kings Beach, Caloundra.

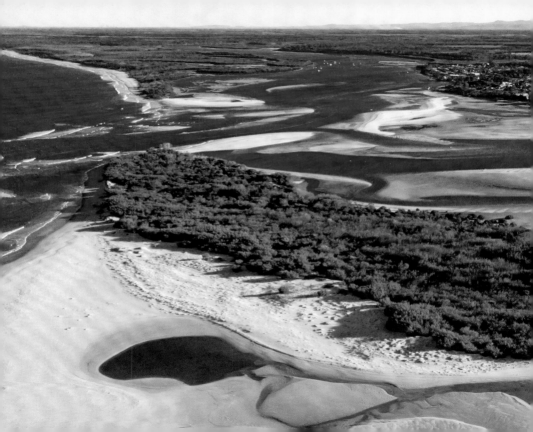

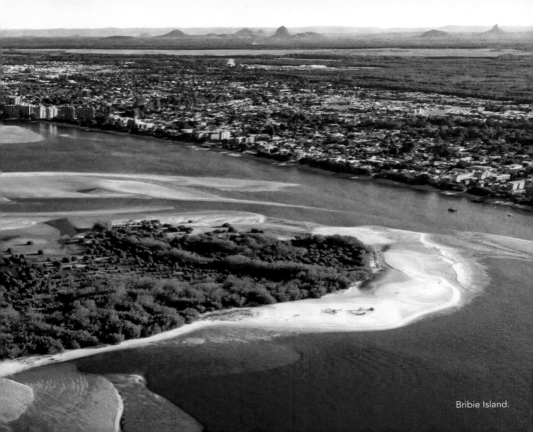
Bribie Island.

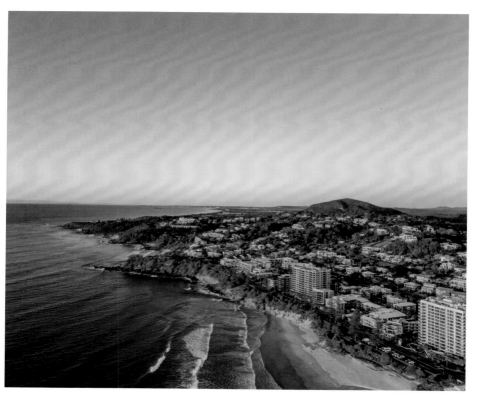

Sunshine Coast beach.

Noosa National Park.

Noosa Heads

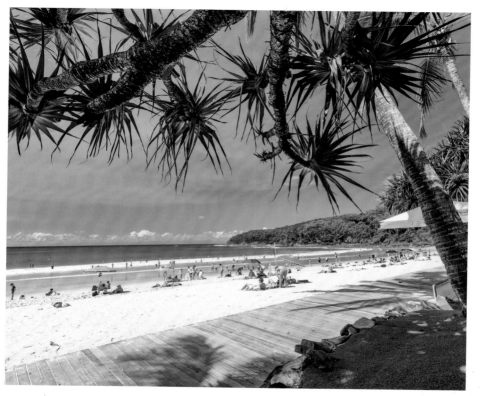

Noosa.

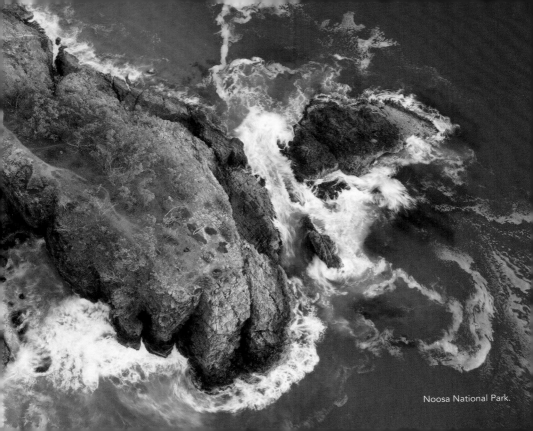
Noosa National Park.

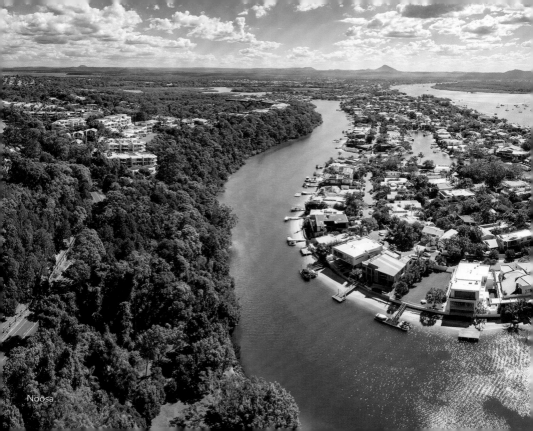
Noosa.

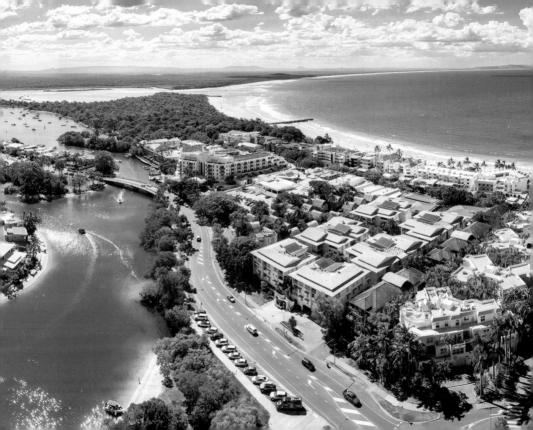

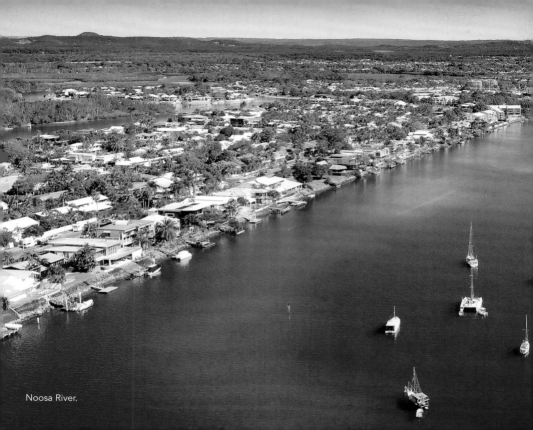
Noosa River.

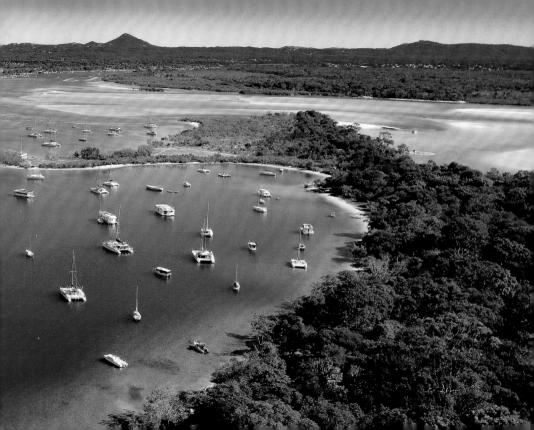

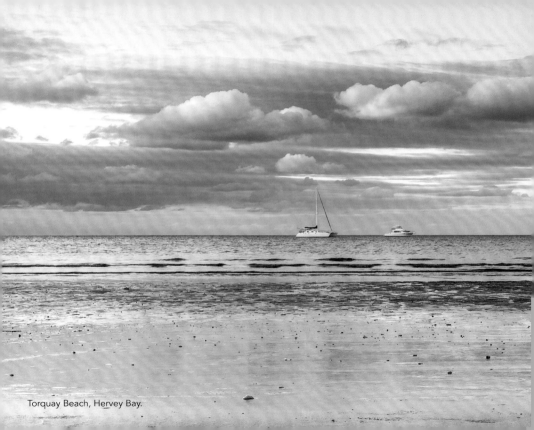
Torquay Beach, Hervey Bay.

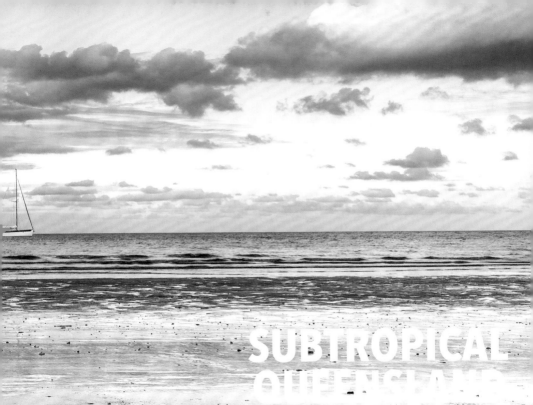

SUBTROPICAL
QUEENSLAND

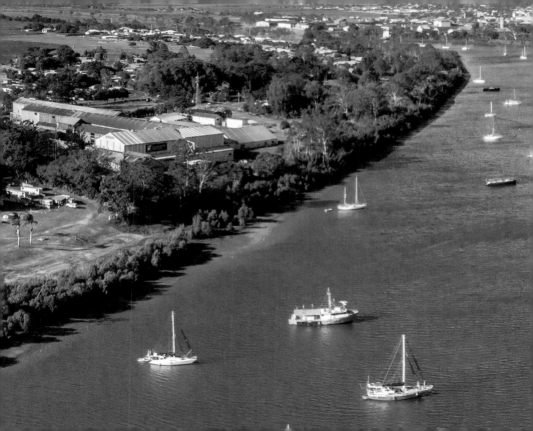

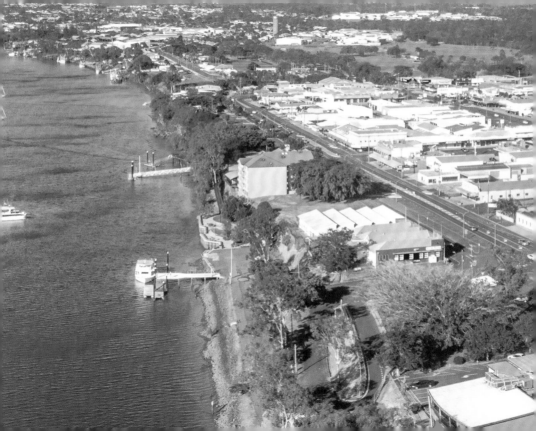

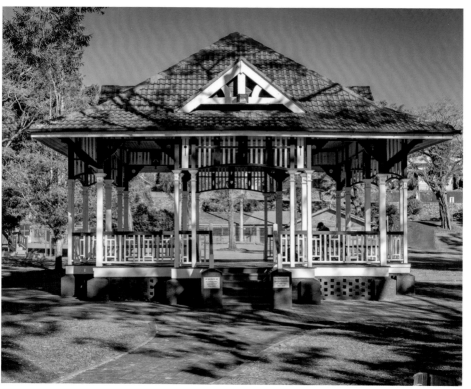

Memorial Park, Gympie.

Gympie Town Hall.

Gympie.

Bundaberg Rum Distillery and Museum.

Scarness Jetty, Hervey Bay.

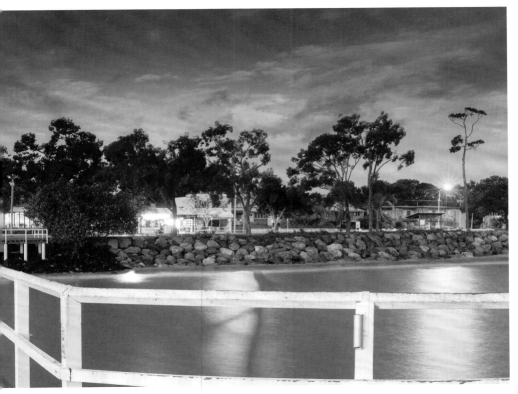

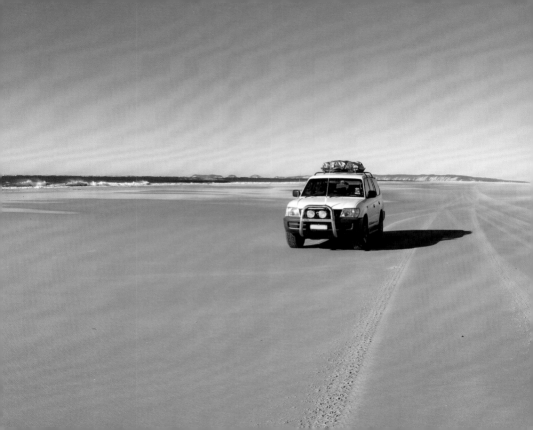

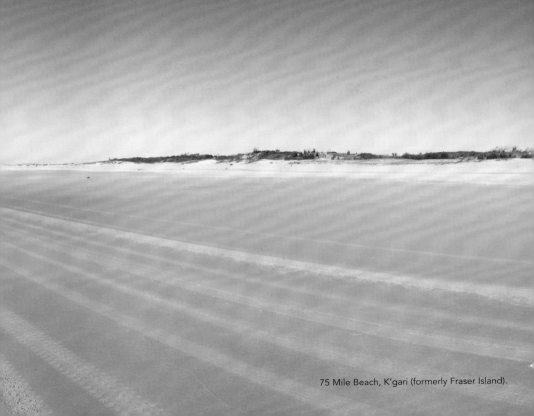

75 Mile Beach, K'gari (formerly Fraser Island).

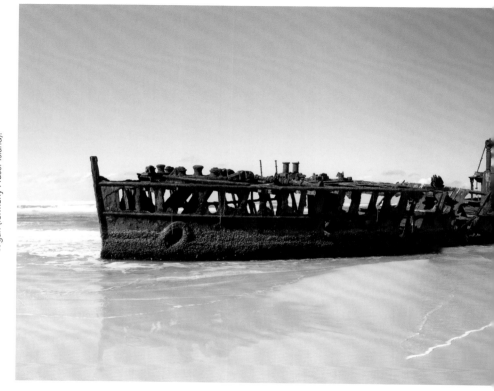

K'gari (formerly Fraser Island).

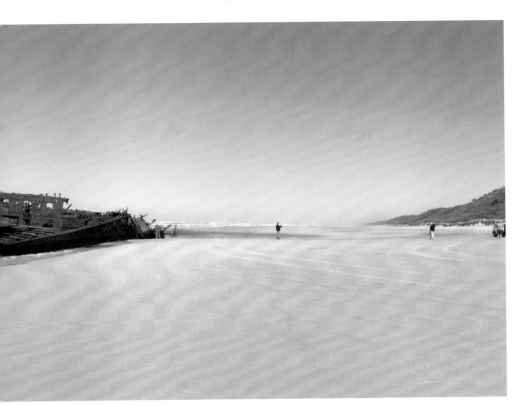

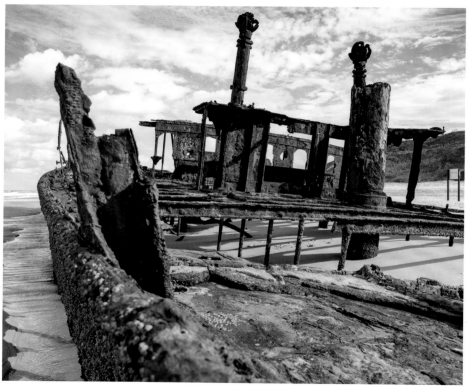

Shipwreck SS Maheno on K'gari (formerly Fraser Island).

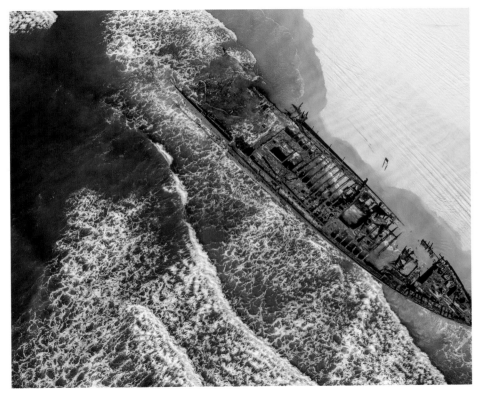

K'gari (formerly Fraser Island) shipwreck on sand.

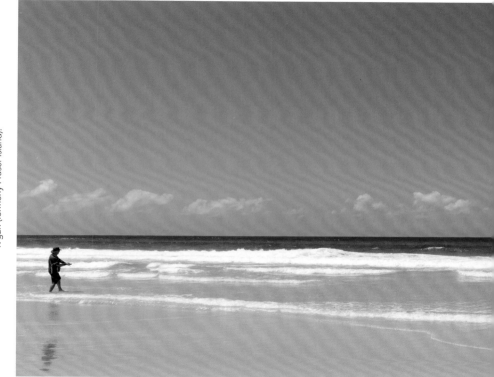

K'gari (formerly Fraser Island).

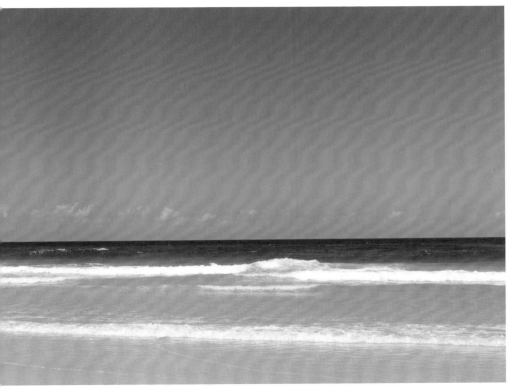

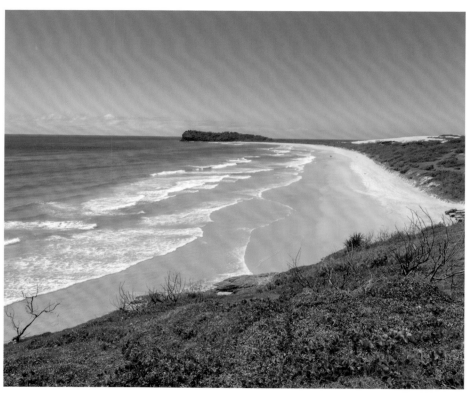

K'gari (formerly Fraser Island).

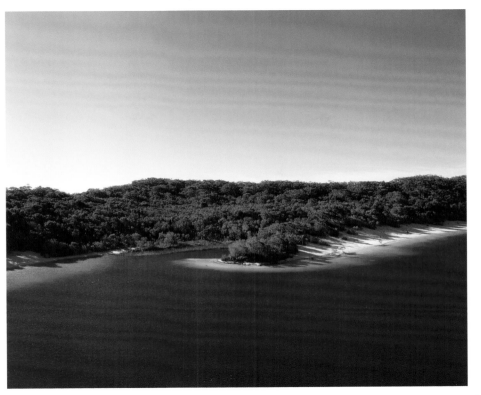

K'gari-Fraser Island.

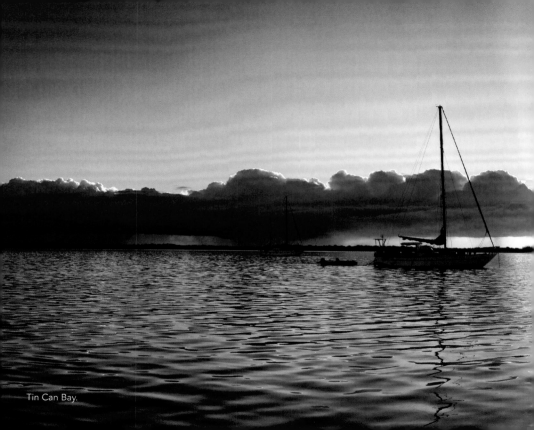
Tin Can Bay.

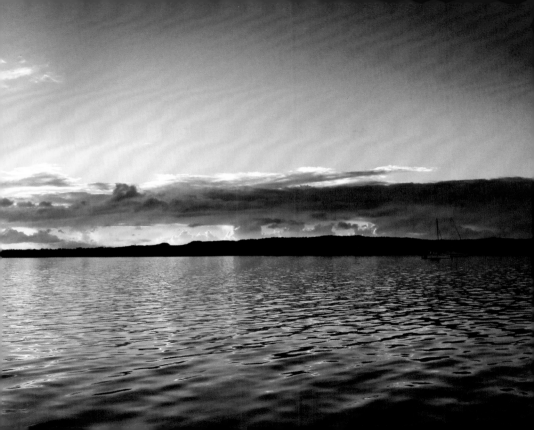

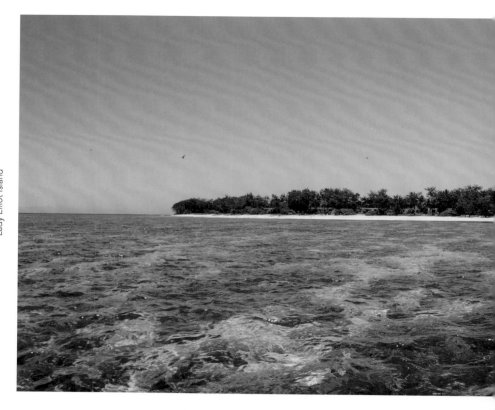

Lady Elliot Island

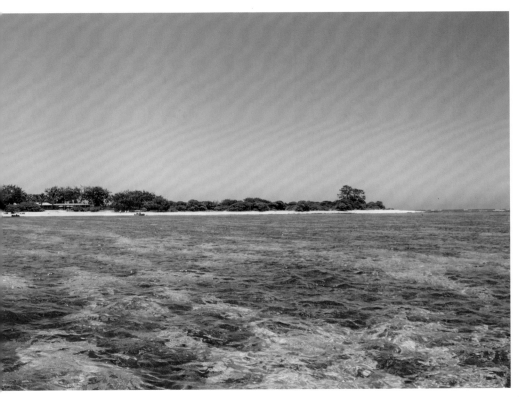

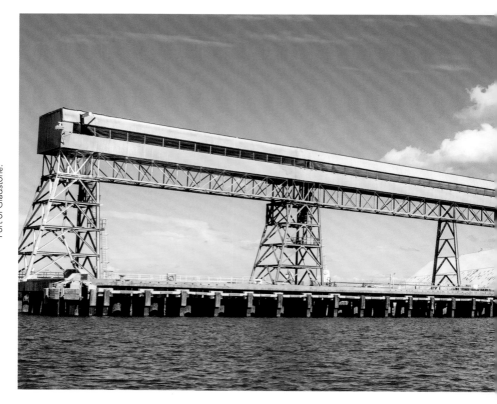

Port of Gladstone.

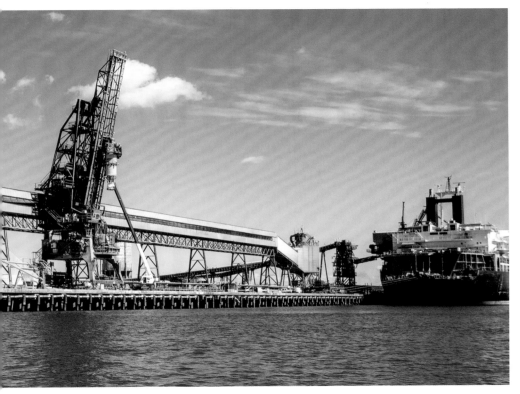

Tondoon Botanic Gardens in Gladstone.

Capricorn Caves in the Mount Etna Caves National Park.

157

Heritage Hotel Rockhampton.

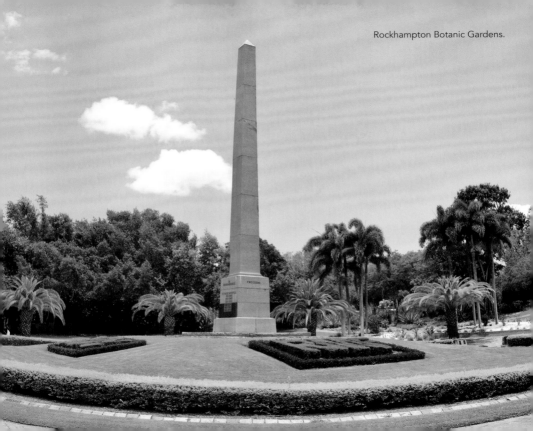

Rockhampton Botanic Gardens.

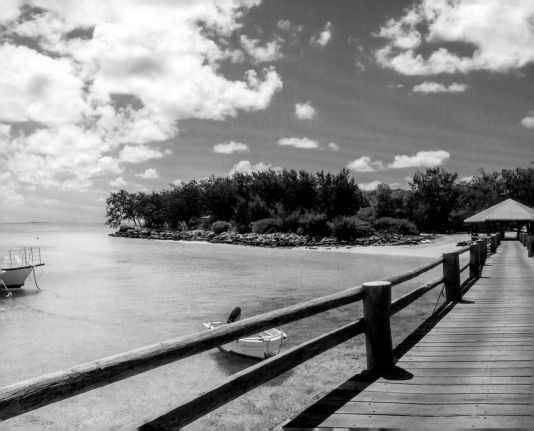

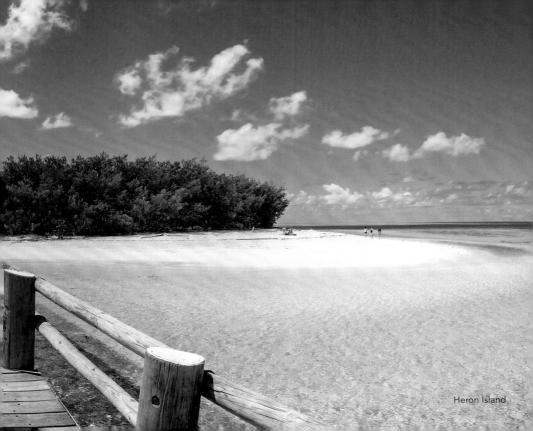

Heron Island

Great Keppel (Wop-pa) Island.

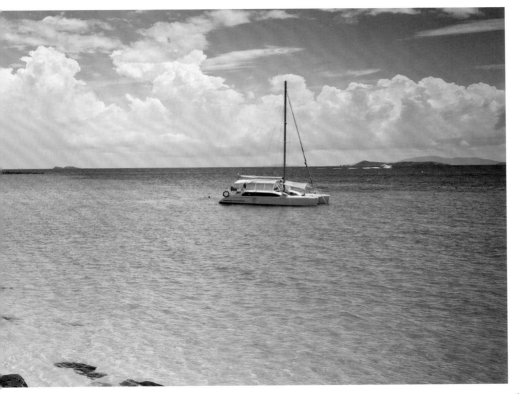

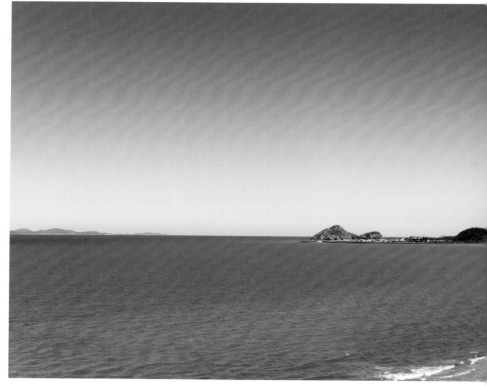

Yeppoon.

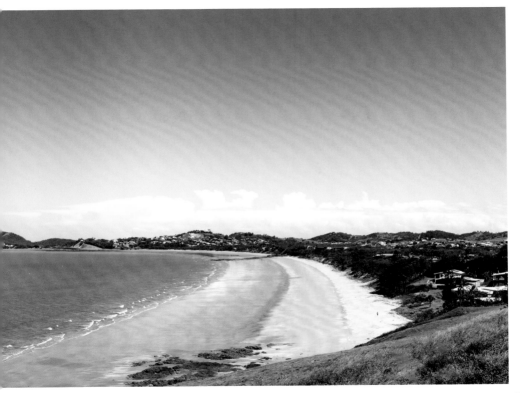

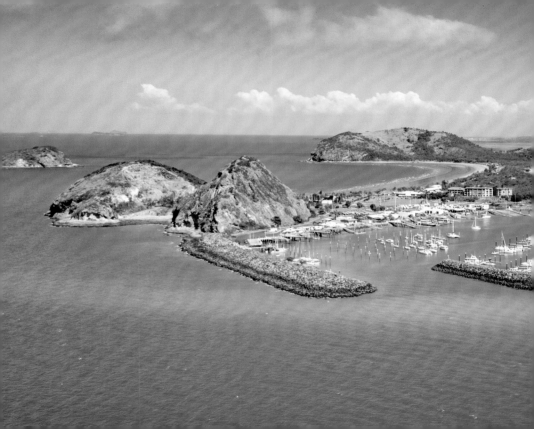

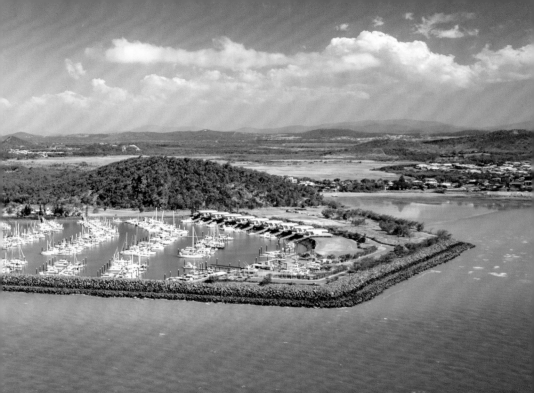

Keppel Bay Marina.

Yeppoon.

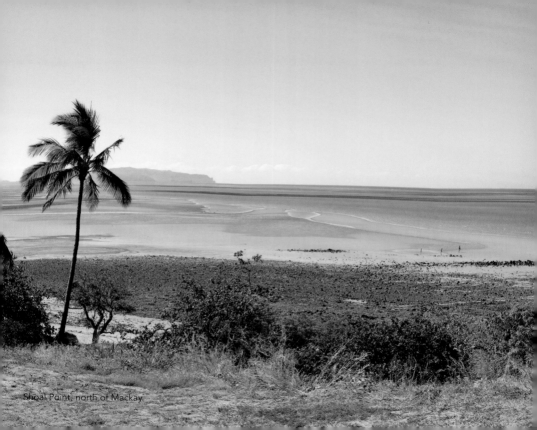

Shoal Point, north of Mackay.

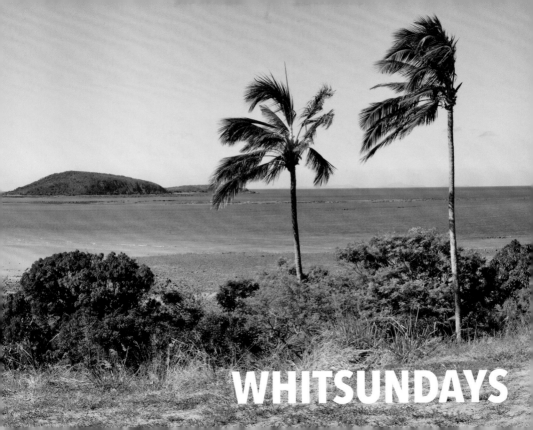

WHITSUNDAYS

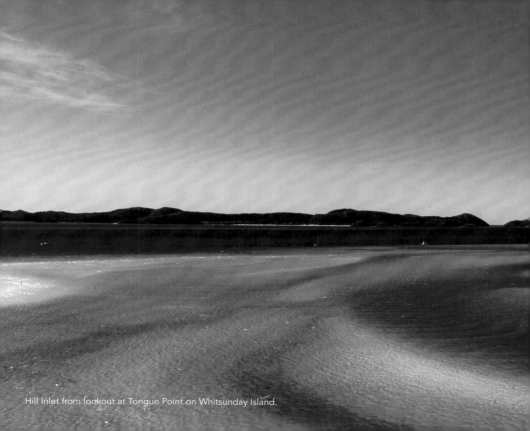

Hill Inlet from lookout at Tongue Point on Whitsunday Island.

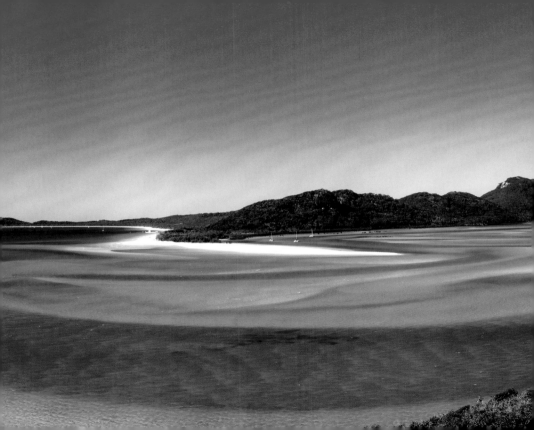

Mackay Harbour.

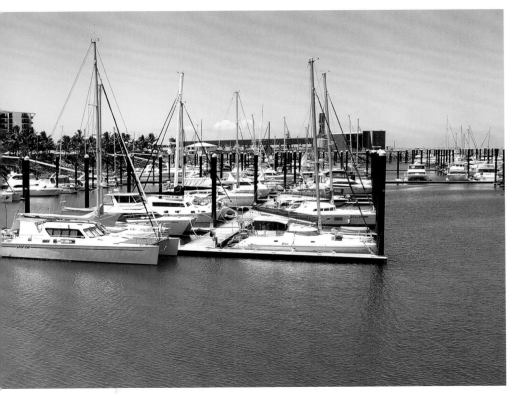

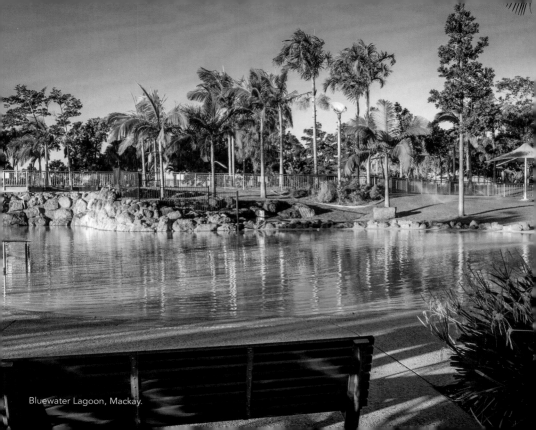

Bluewater Lagoon, Mackay.

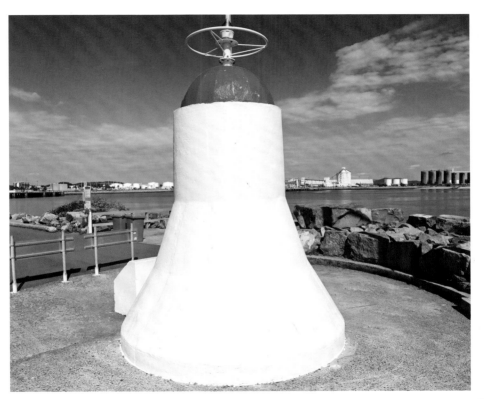

Harbour Light, Mackay.

Kangaroos at Cape Hillsborough National Park, north of Mackay.

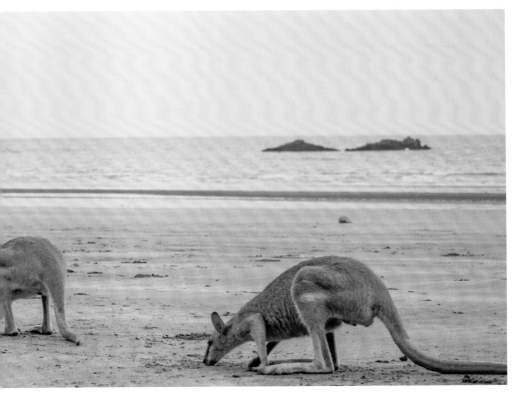

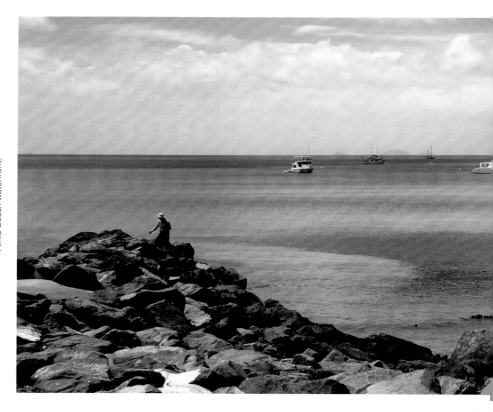

Airlie Beach waterfront.

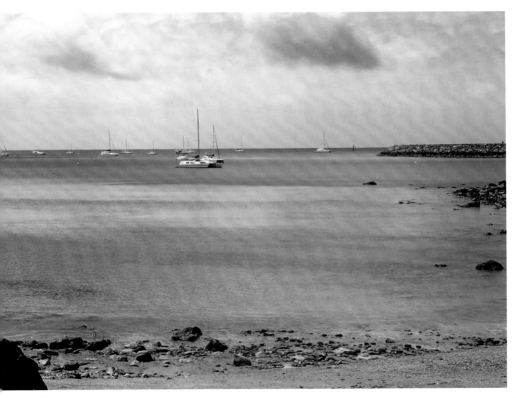

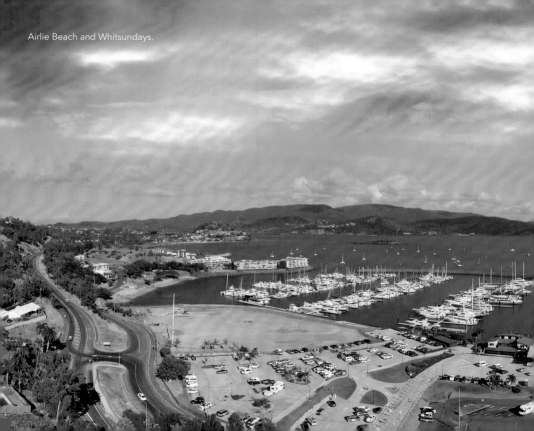
Airlie Beach and Whitsundays.

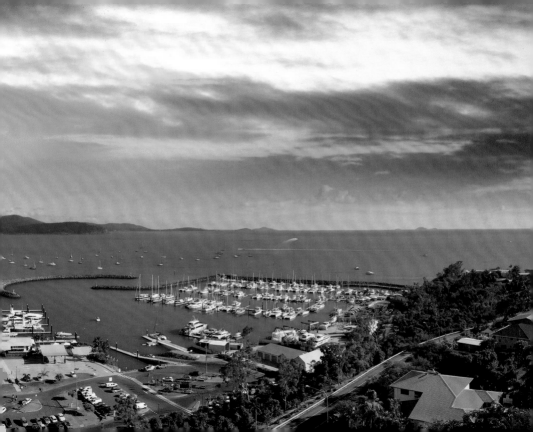

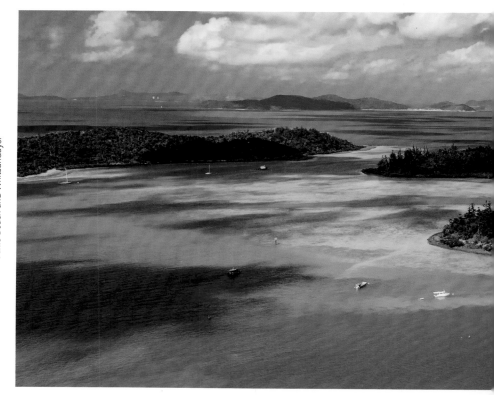

Airlie Beach and Whitsundays.

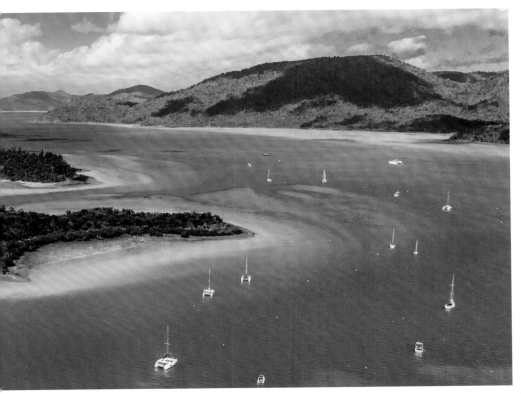

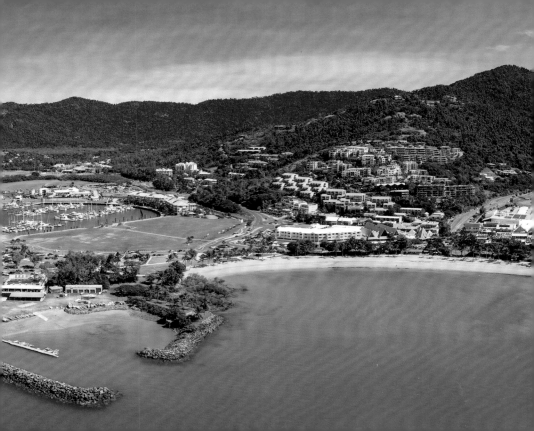

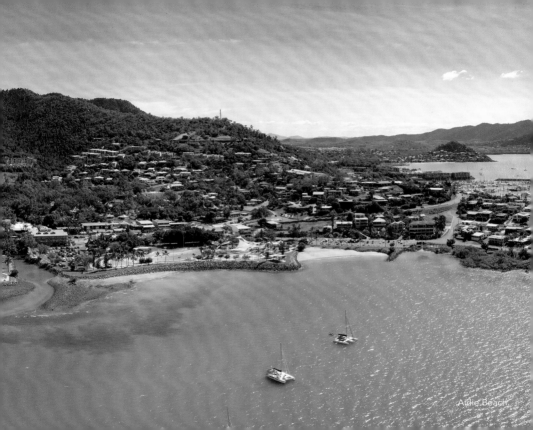
Airlie Beach

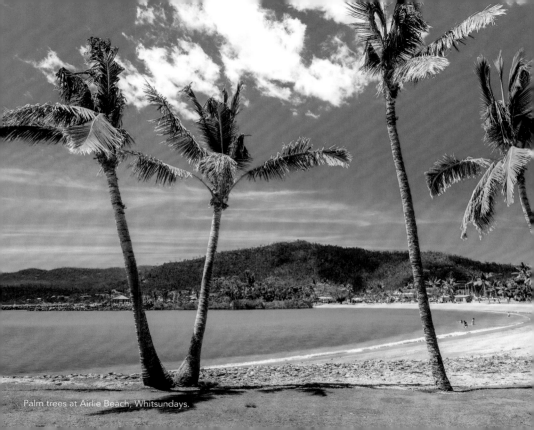

Palm trees at Airlie Beach, Whitsundays.

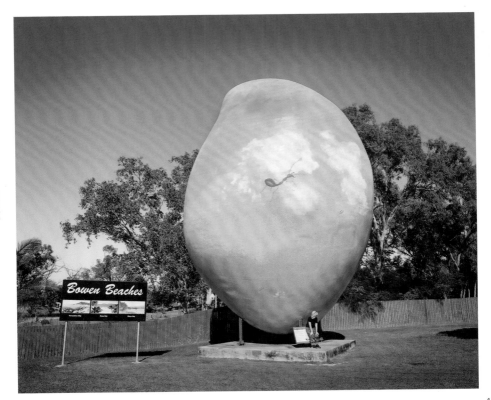

Bowen.

Horseshoe Bay, Bowen.

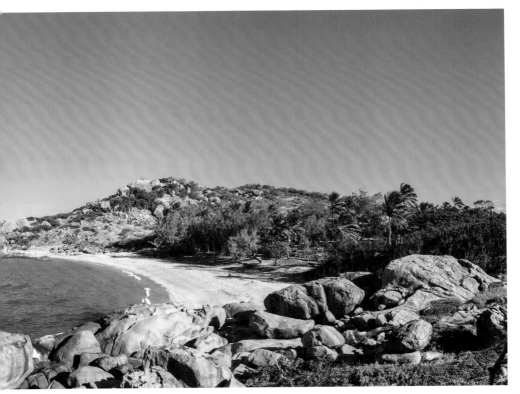

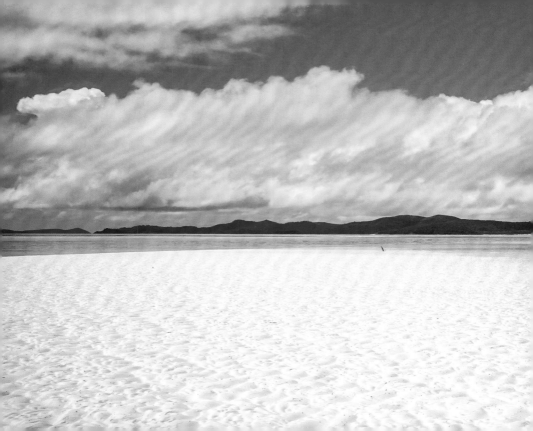

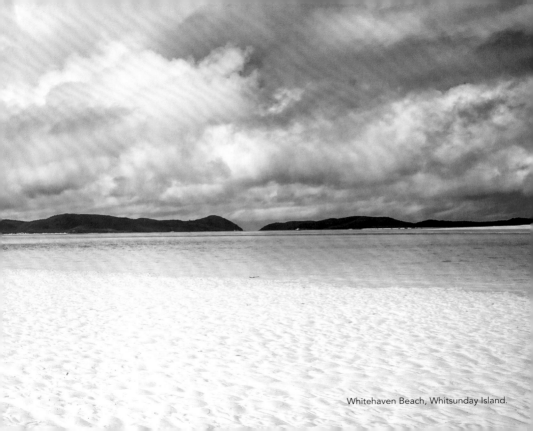
Whitehaven Beach, Whitsunday Island.

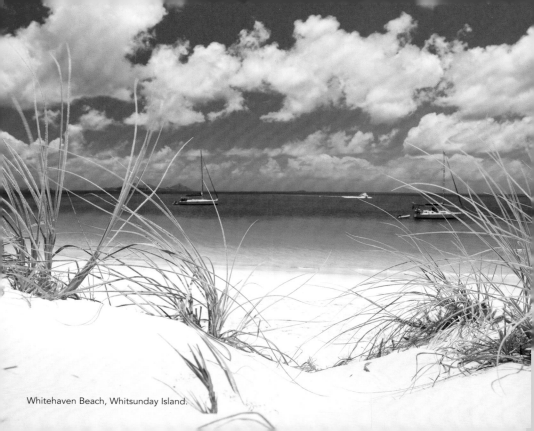

Whitehaven Beach, Whitsunday Island.

Catseye Beach, Hamilton Island.

Whitehaven Beach, Whitsunday Island.

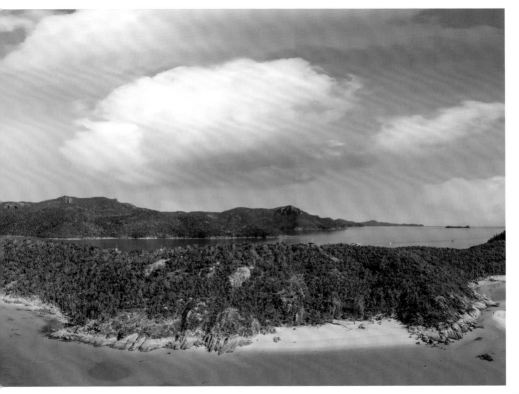

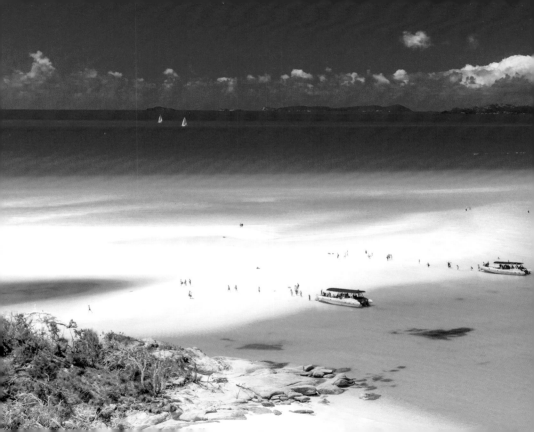

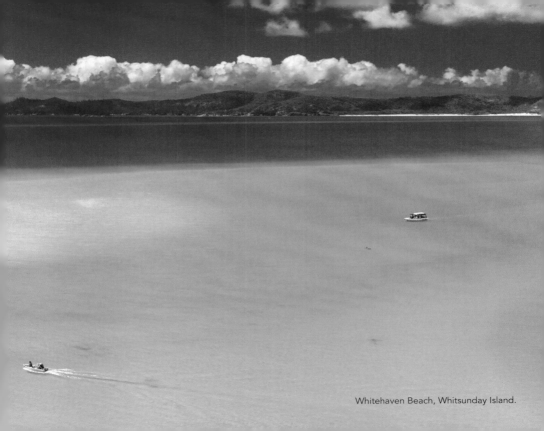

Whitehaven Beach, Whitsunday Island.

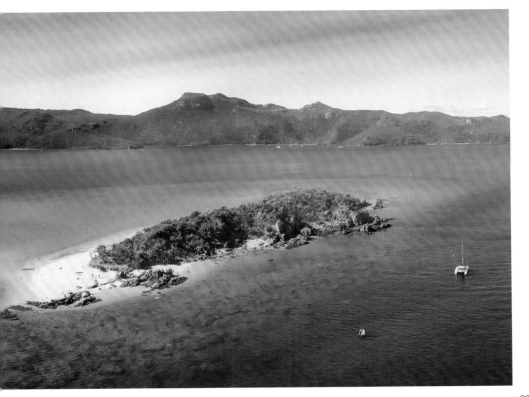

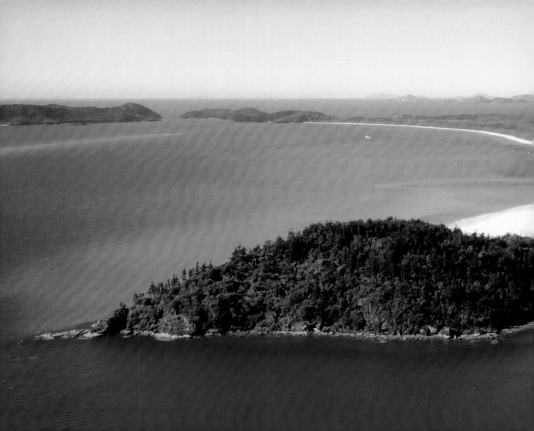

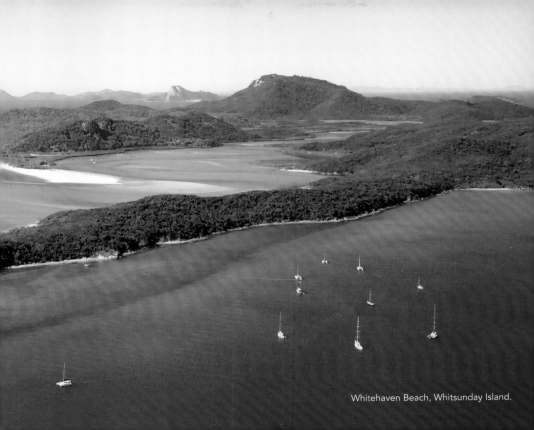

Whitehaven Beach, Whitsunday Island.

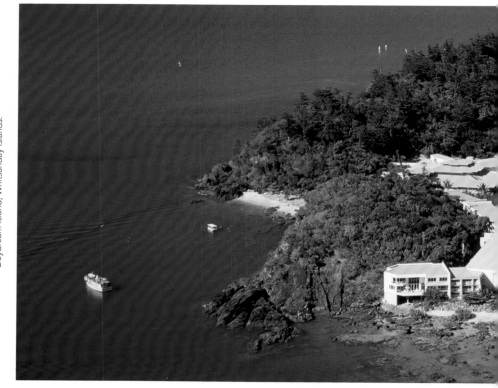

Daydream Island, Whitsunday Islands.

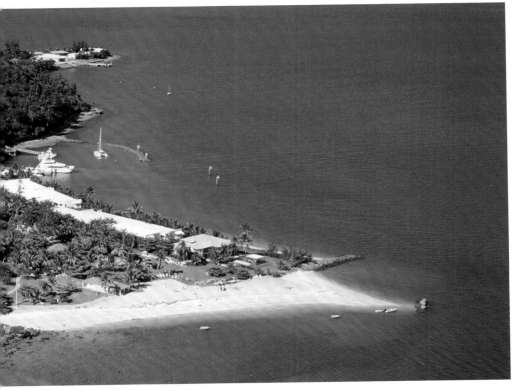

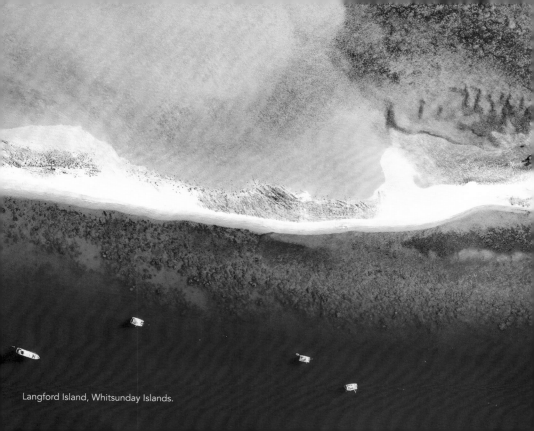

Langford Island, Whitsunday Islands.

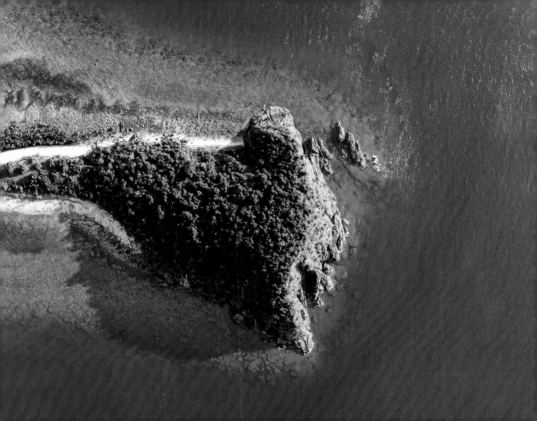

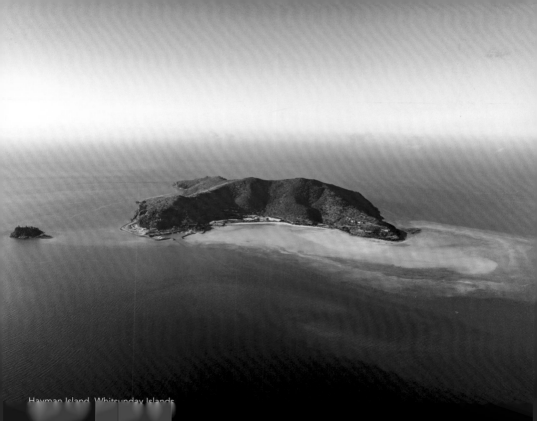
Hayman Island, Whitsunday Islands

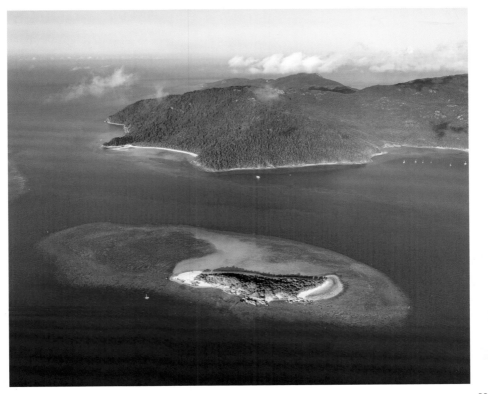

Black Island with Hook Island in the background.

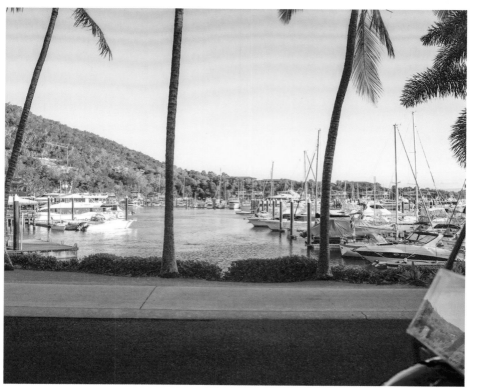

Hamilton Island, Whitsunday Islands.

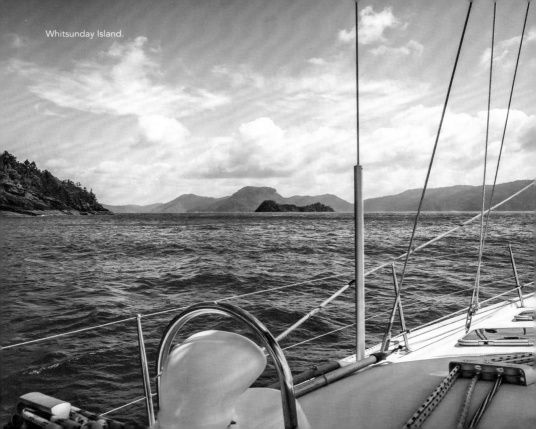

Whitsunday Island.

Daydream Island, Whitsunday Islands.

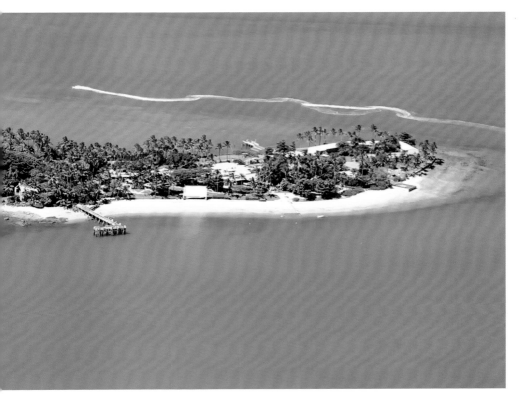

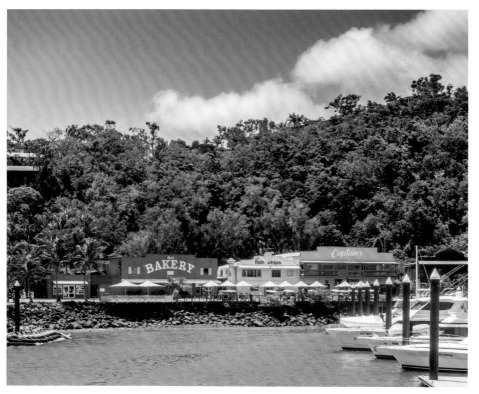

Hamilton Island, Whitsunday Islands.

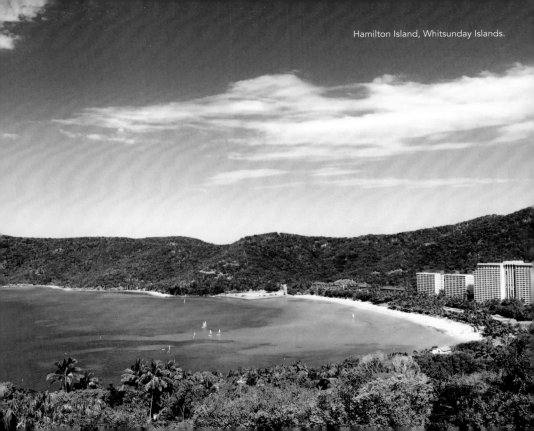

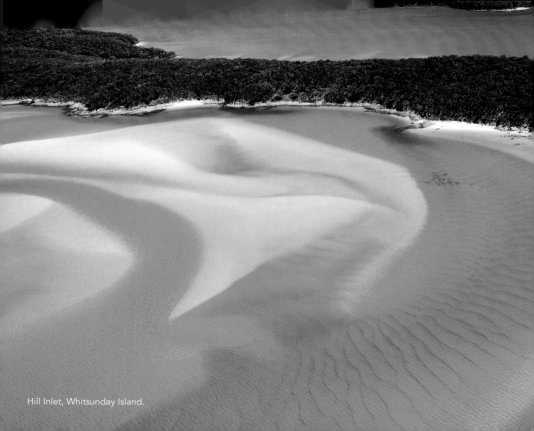

Hill Inlet, Whitsunday Island.

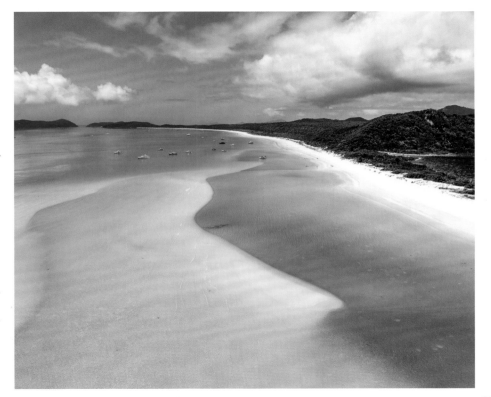

Whitehaven Beach, Whitsunday Island.

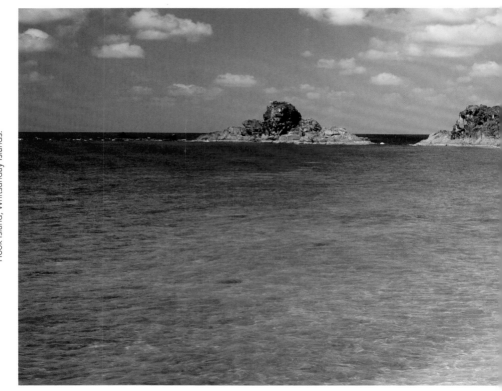

Hook Island, Whitsunday Islands.

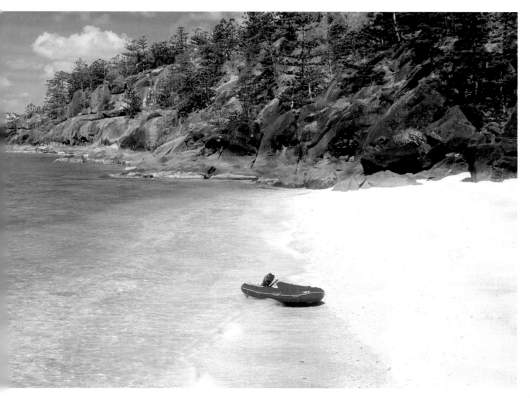

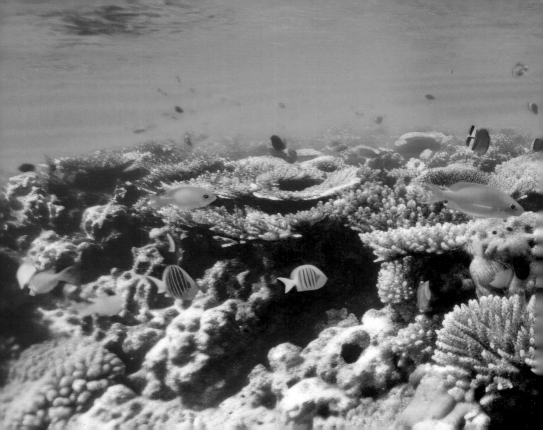

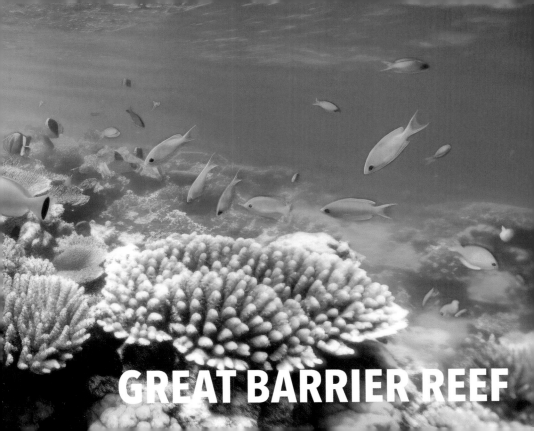

GREAT BARRIER REEF

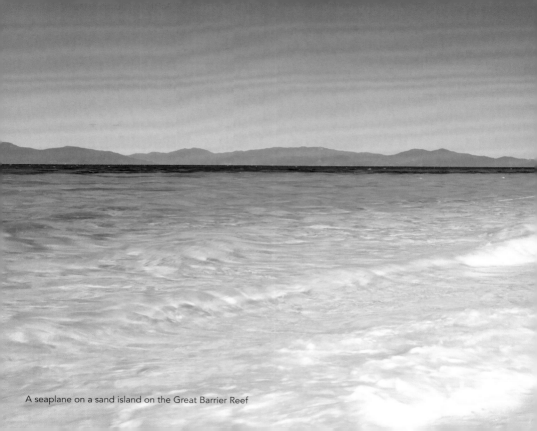

A seaplane on a sand island on the Great Barrier Reef

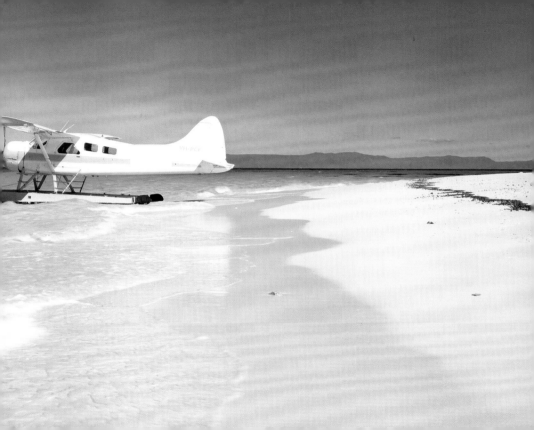

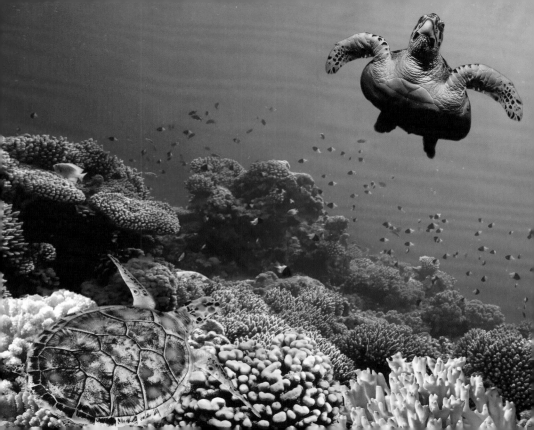

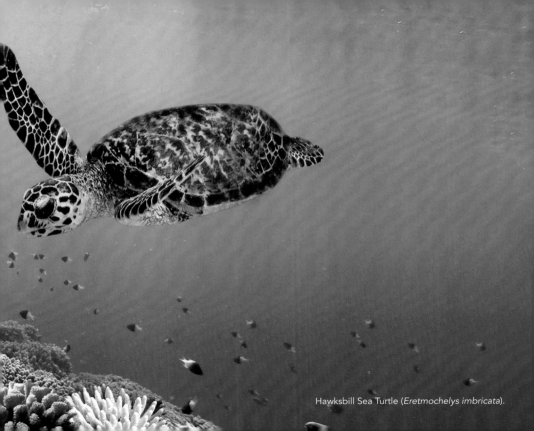

Hawksbill Sea Turtle (*Eretmochelys imbricata*).

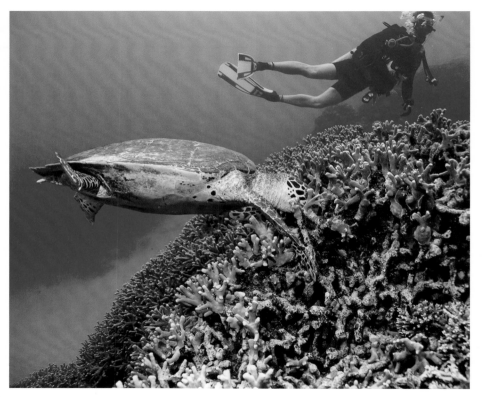

Green Sea Turtle.

Heart Reef.

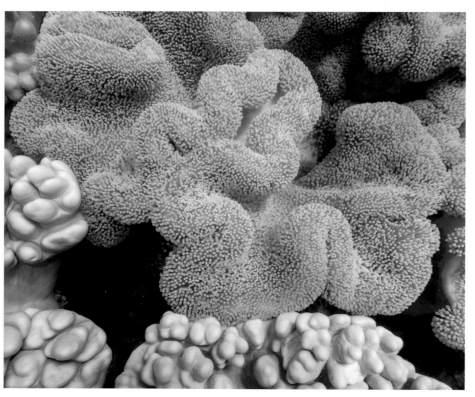

Coral on the Great Barrier Reef.

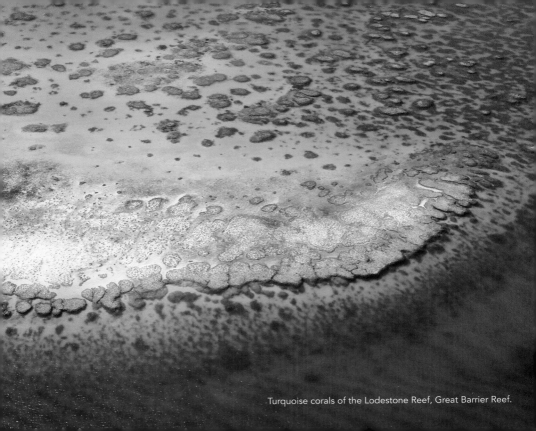

Turquoise corals of the Lodestone Reef, Great Barrier Reef.

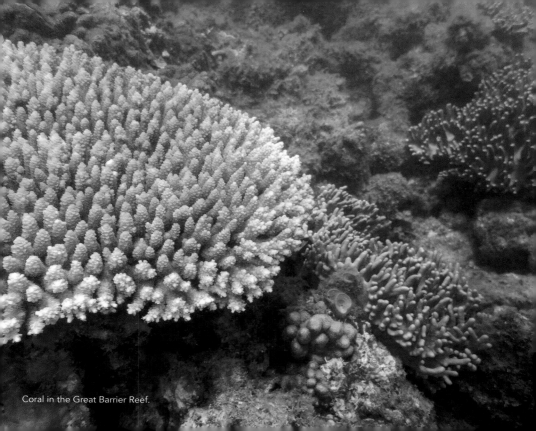

Coral in the Great Barrier Reef.

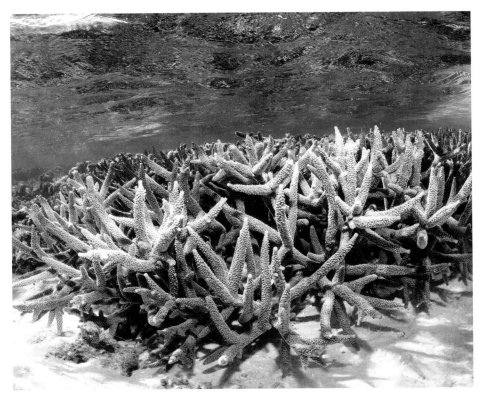

Coral reef, Heron Island

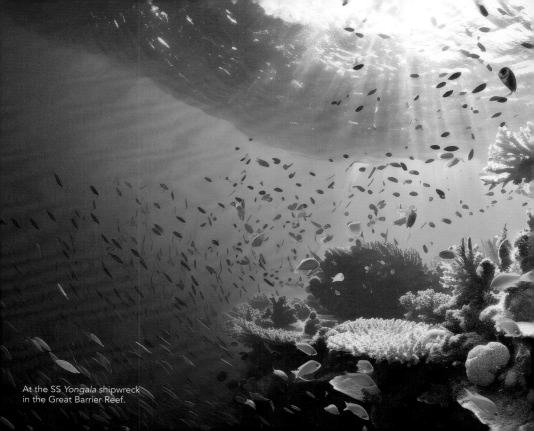

At the SS *Yongala* shipwreck
in the Great Barrier Reef.

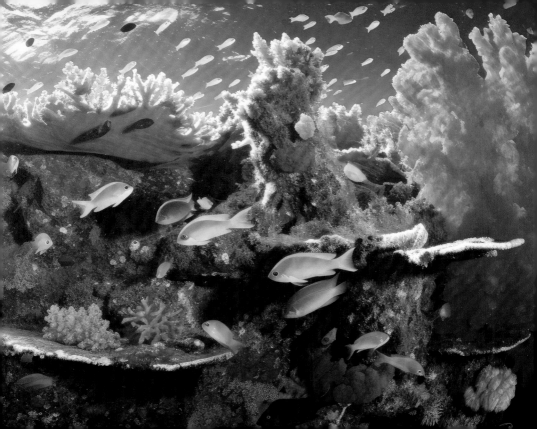

Great Barrier Reef Marine Park.

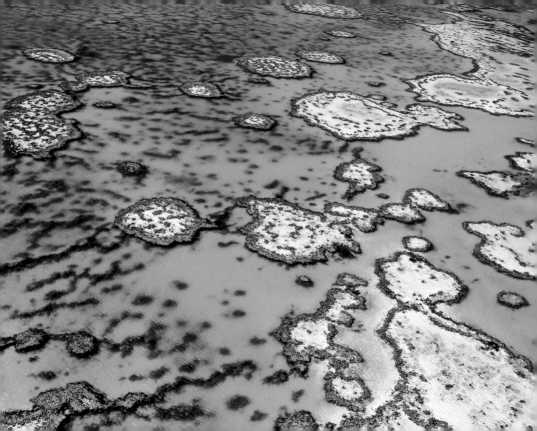

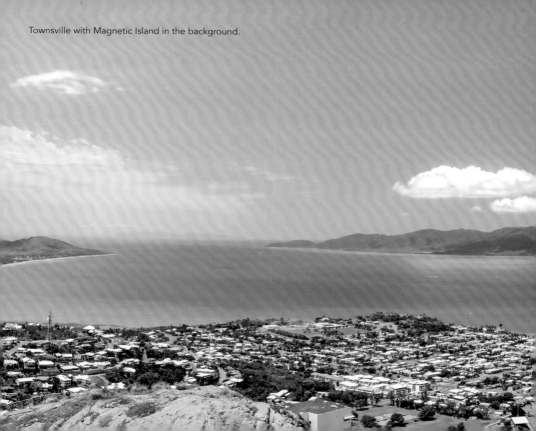

Townsville with Magnetic Island in the background.

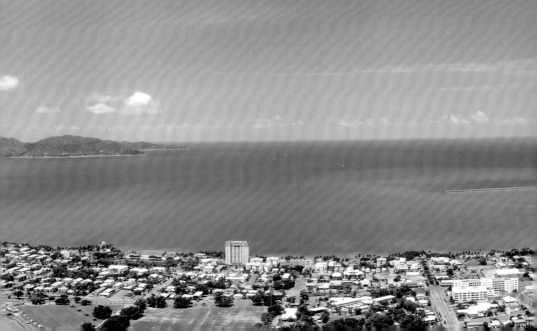

# NORTH QUEENSLAND

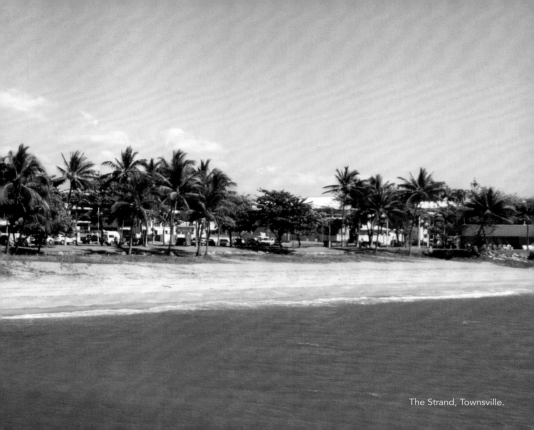
The Strand, Townsville.

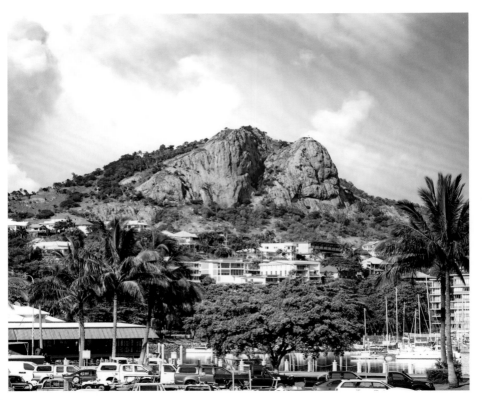

Castle Hill, Townsville.

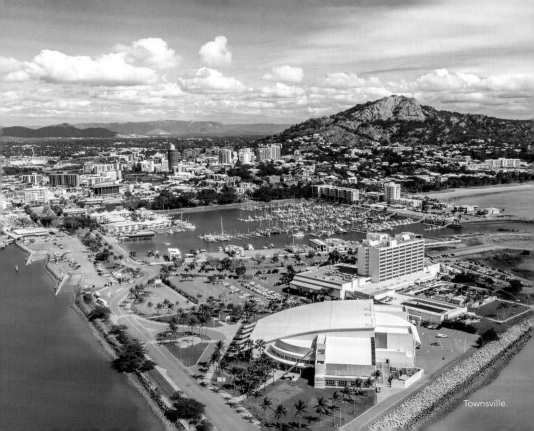

Townsville.

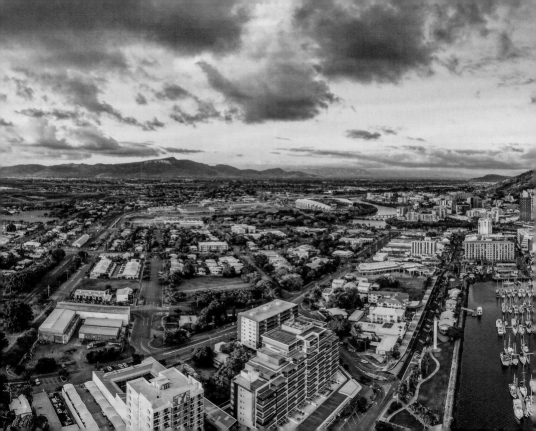

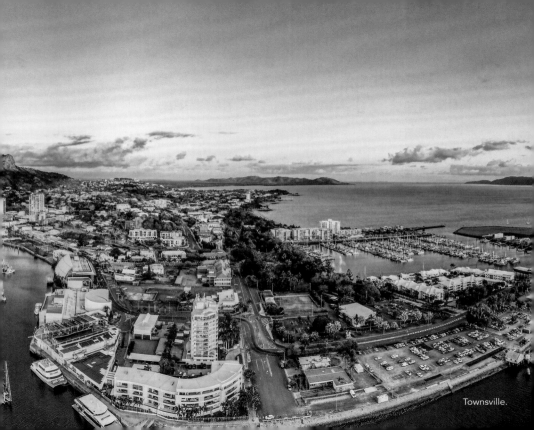
Townsville.

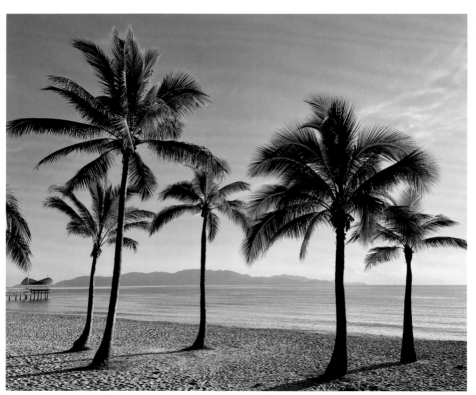

The Strand, Townsville.

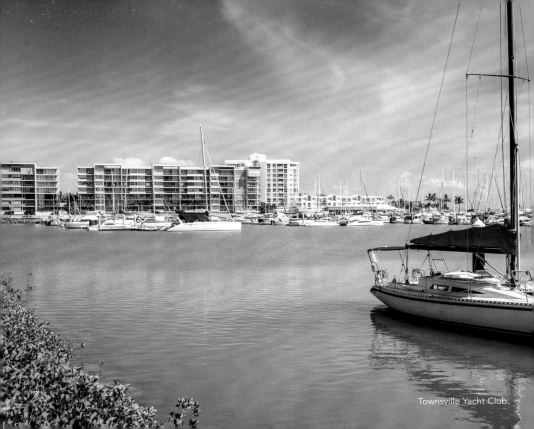
Townsville Yacht Club.

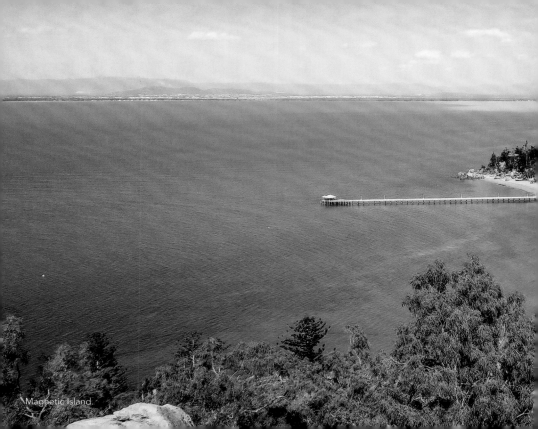
Magnetic Island.

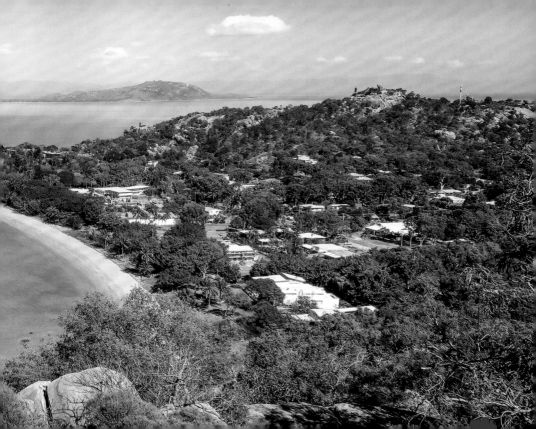

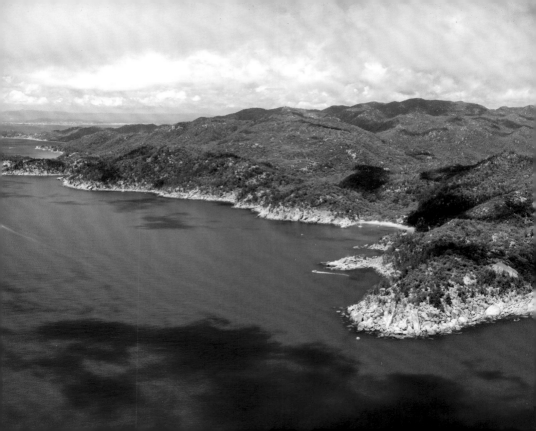

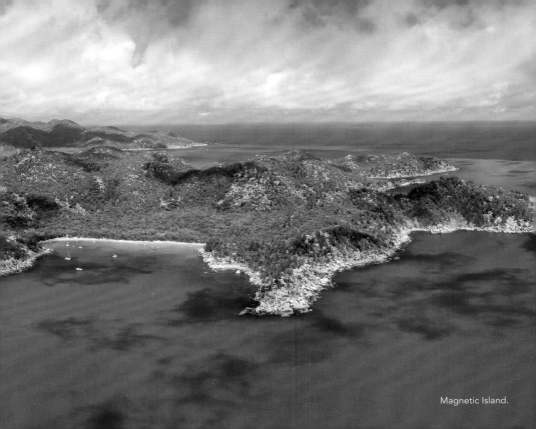

Magnetic Island.

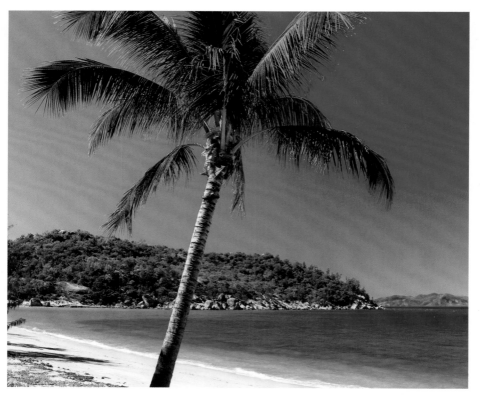

Magnetic Island.

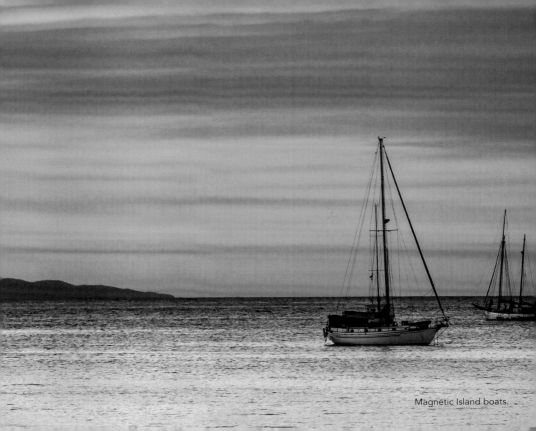
Magnetic Island boats.

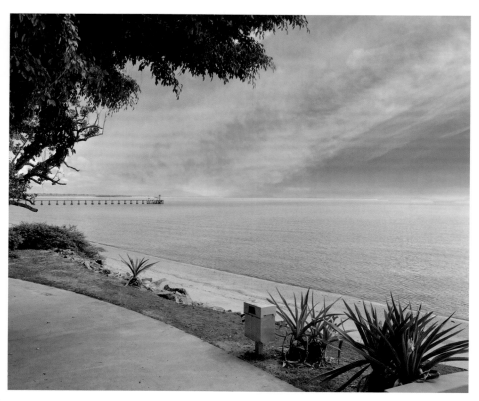

Cardwell.

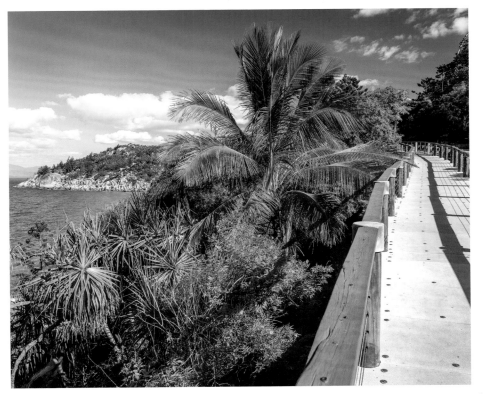

Magnetic Island.

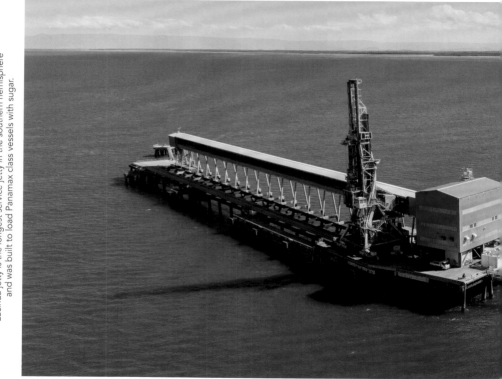

Lucinda jetty is the longest service jetty in the southern hemisphere and was built to load Panamax class vessels with sugar.

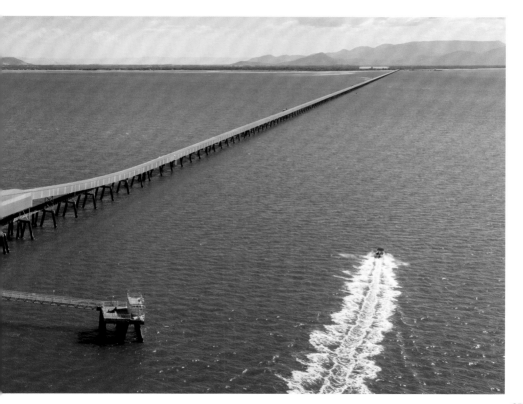

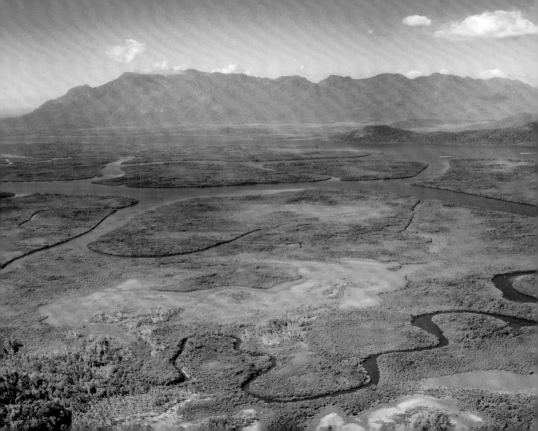

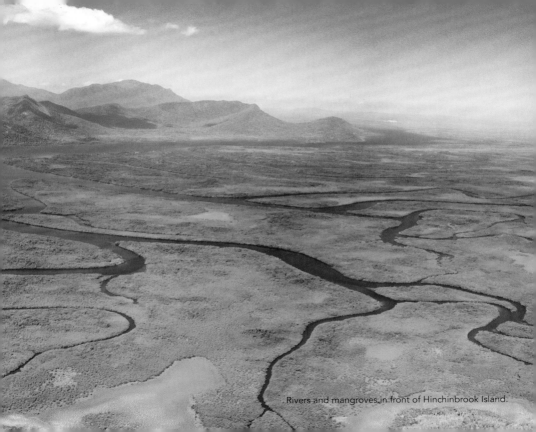

Rivers and mangroves in front of Hinchinbrook Island.

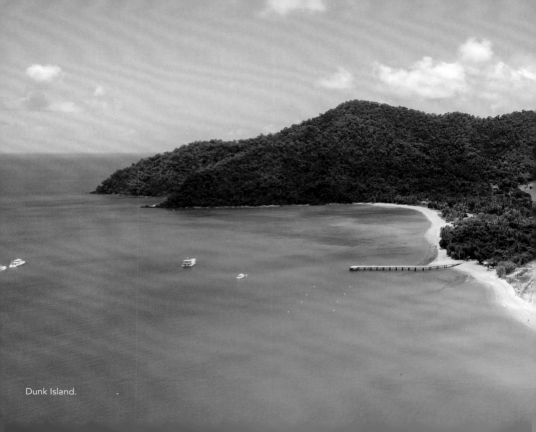
Dunk Island.

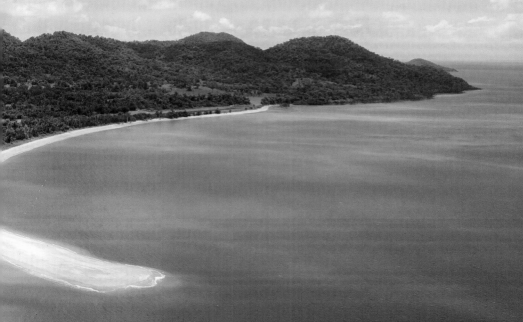

# FAR NORTH QUEENSLAND

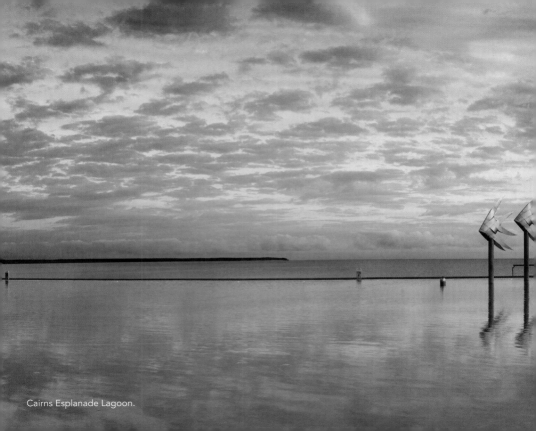

Cairns Esplanade Lagoon.

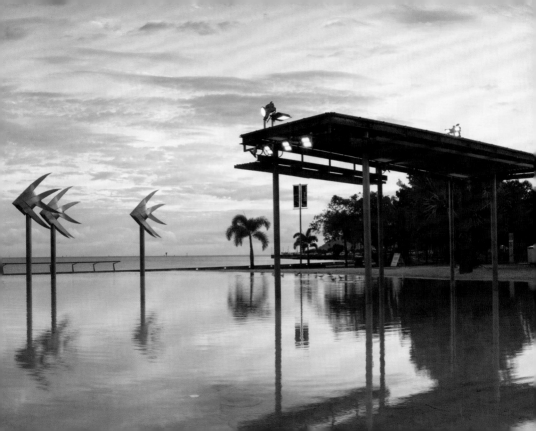

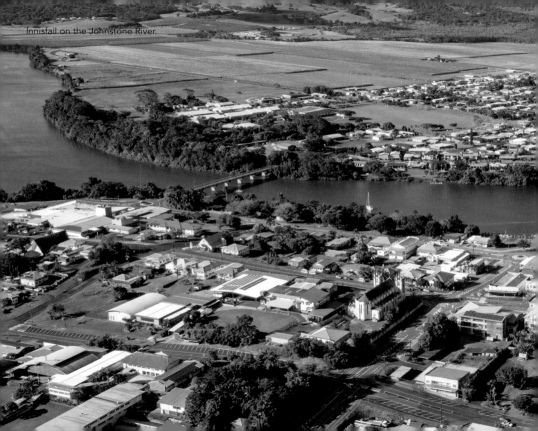
Innisfail on the Johnstone River.

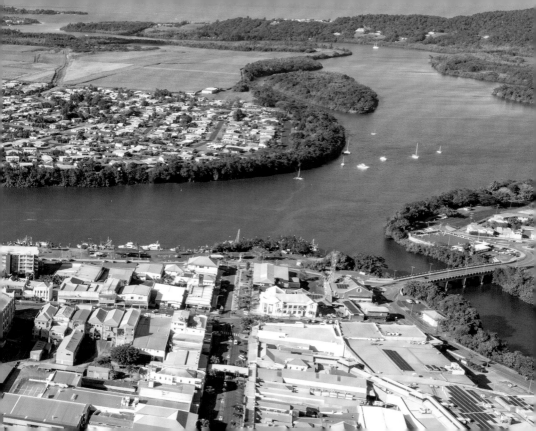

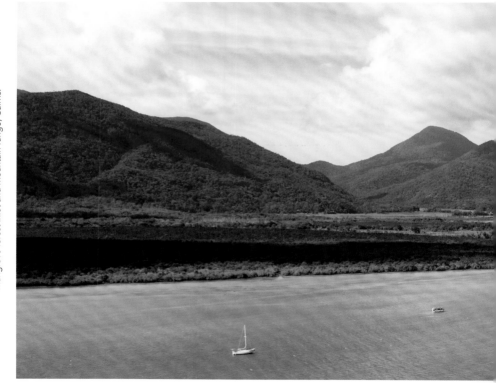

Mangrove forest inlet and mountain range, Cairns.

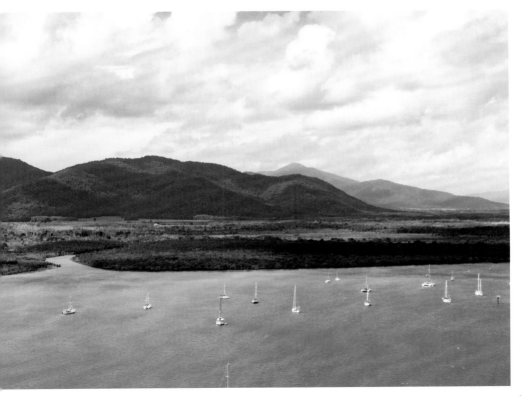

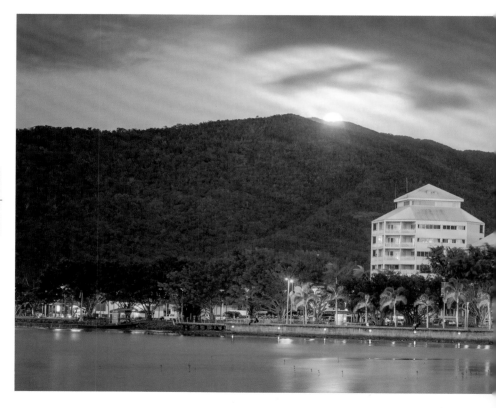

Cairns Esplanade.

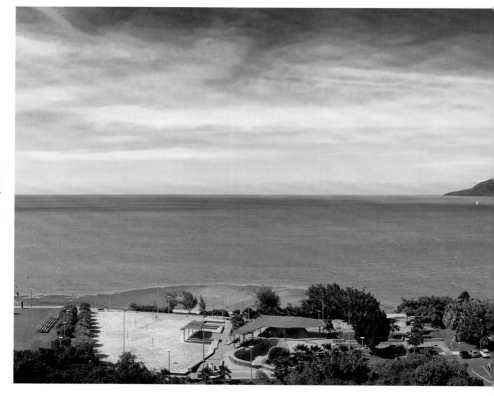

Cairns Esplanade.

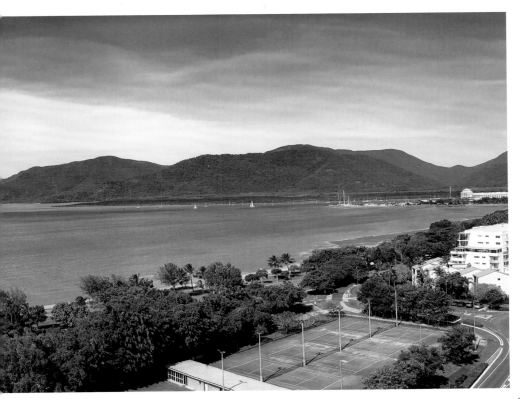

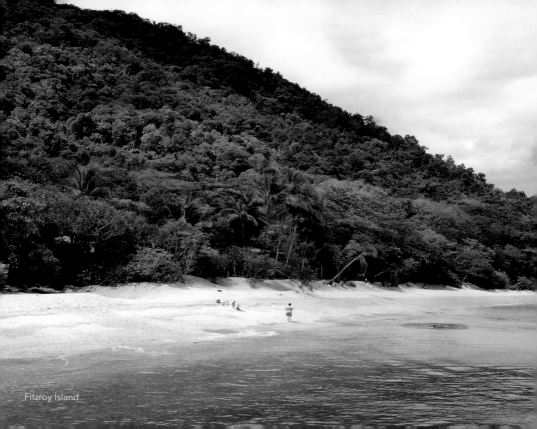
Fitzroy Island.

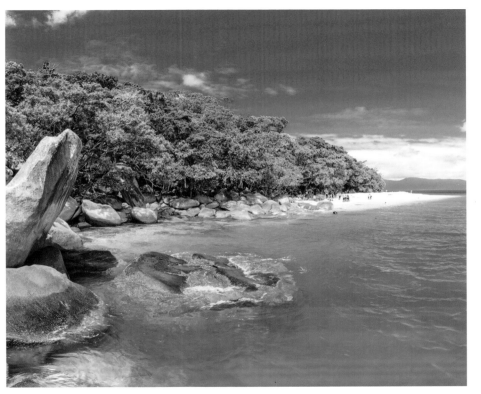

Nudey Beach on Fitzroy Island, Cairns.

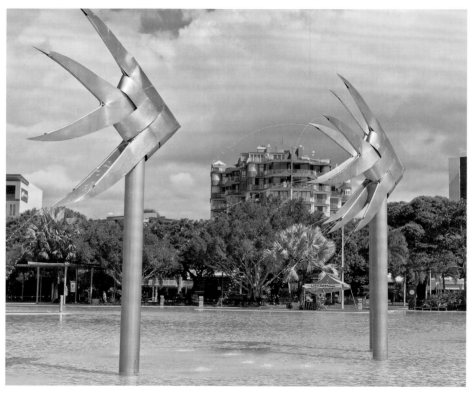

Swimming lagoon on the Esplanade, Cairns.

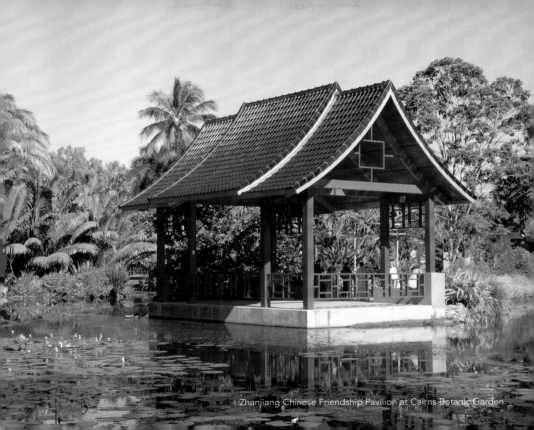

Zhanjiang Chinese Friendship Pavilion at Cairns Botanic Garden.

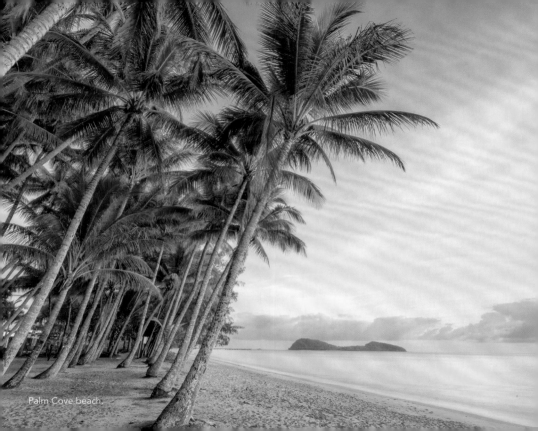

Palm Cove beach.

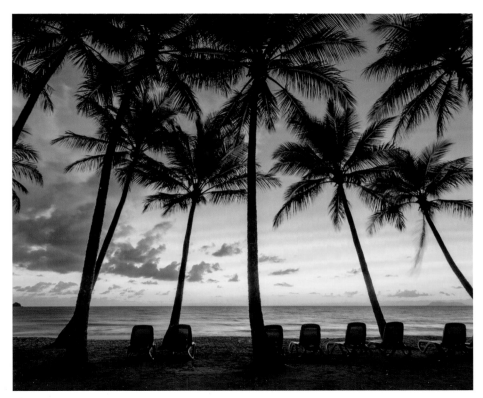

Palm Cove, Cairns.

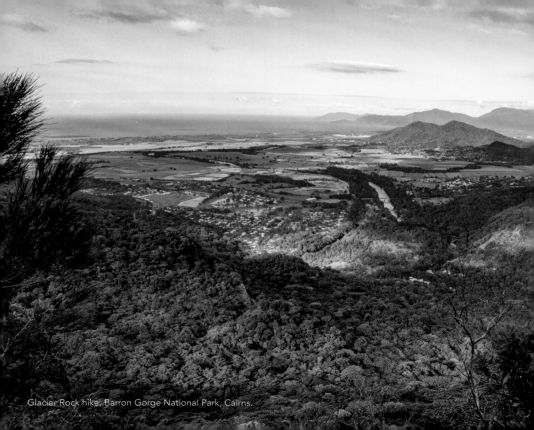
Glacier Rock hike, Barron Gorge National Park, Cairns.

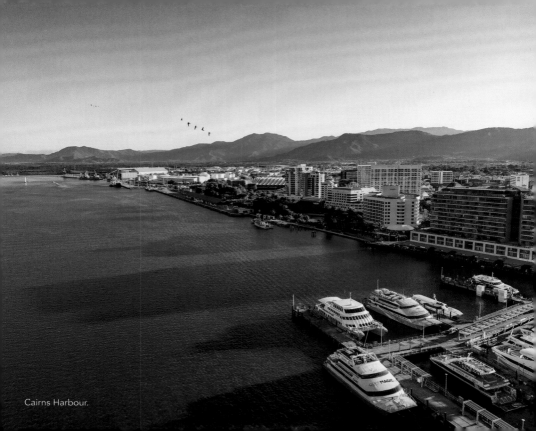
Cairns Harbour.

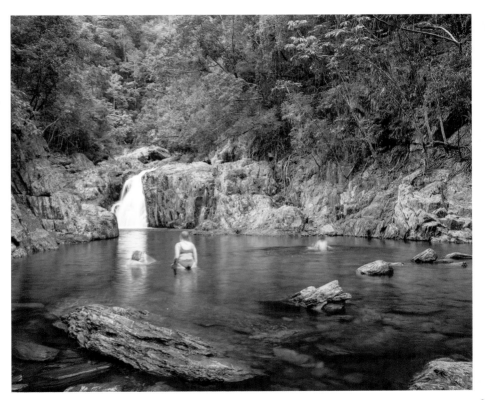

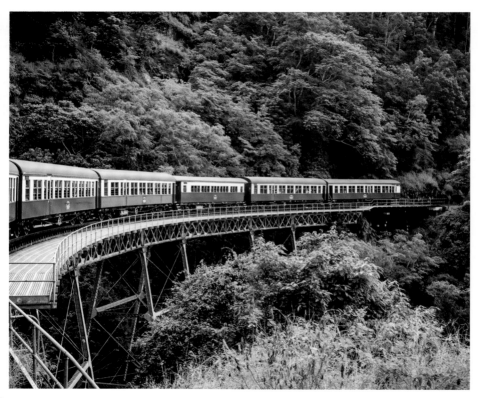

Kuranda Scenic Railway.

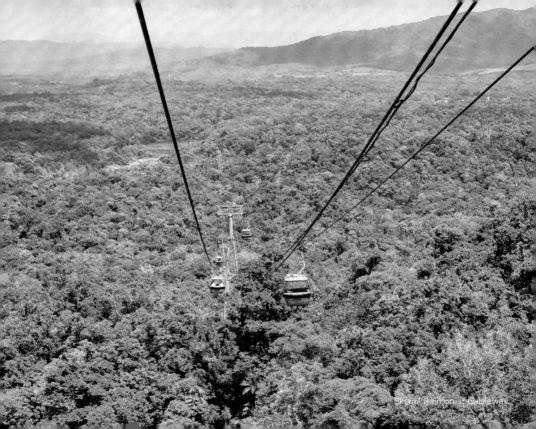

Skyrail Rainforest Cableway

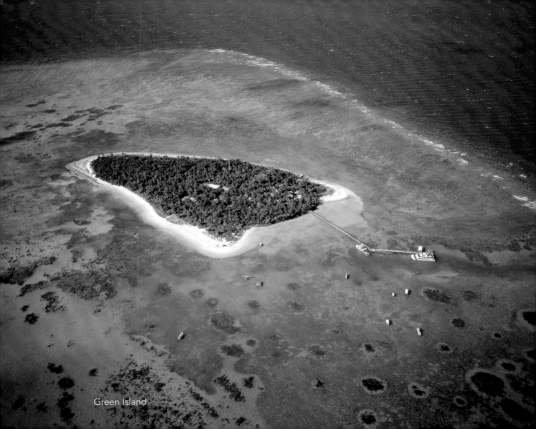

Green Island.

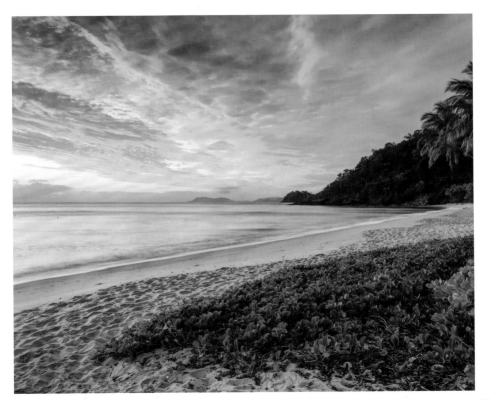

Trinity Beach.

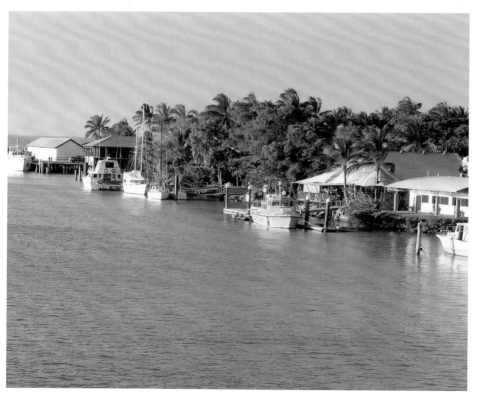

Port Douglas.

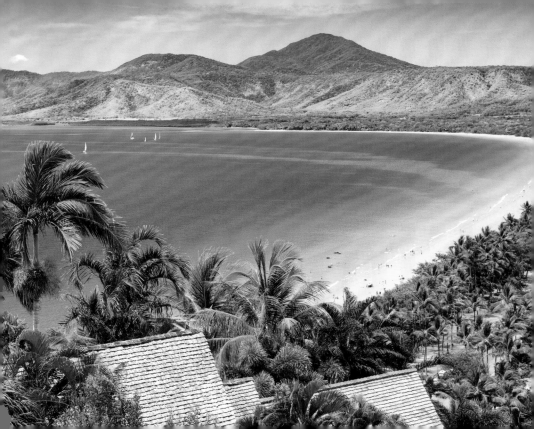

Four Mile Beach, Port Douglas.

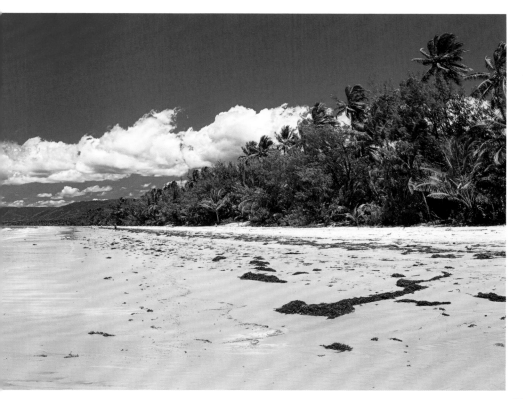

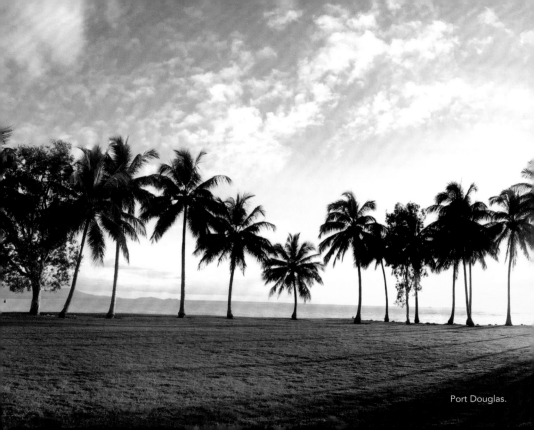

Port Douglas.

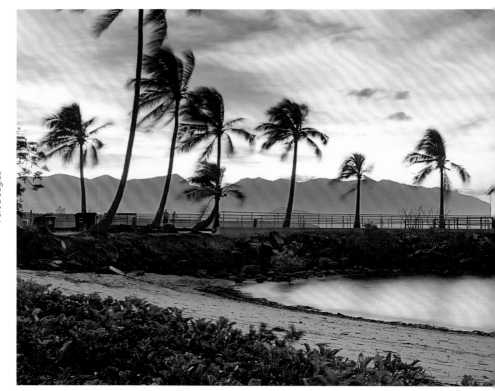

Port Douglas

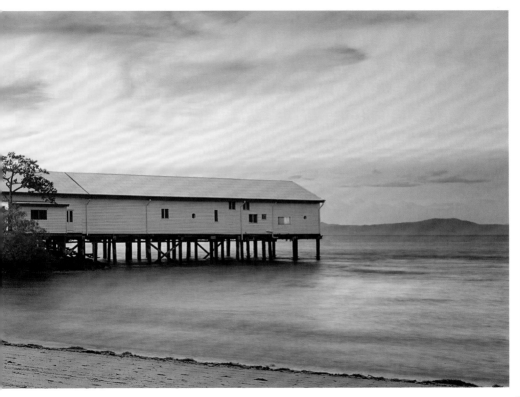

Port Douglas main street.

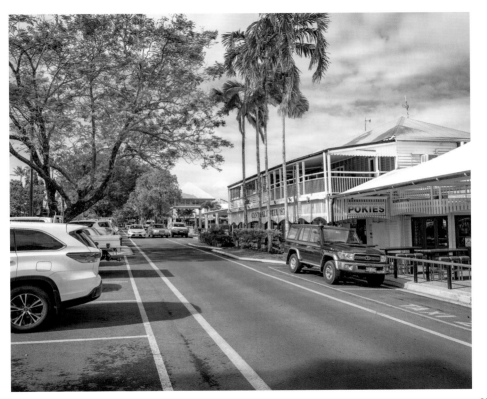

Main shopping street, Port Douglas.

St Mary's by the Sea, Port Douglas.

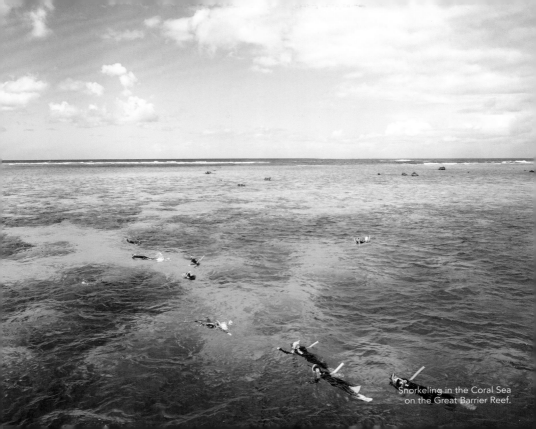

Snorkeling in the Coral Sea
on the Great Barrier Reef.

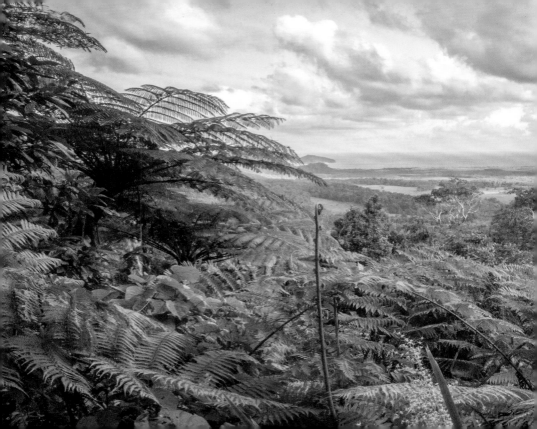

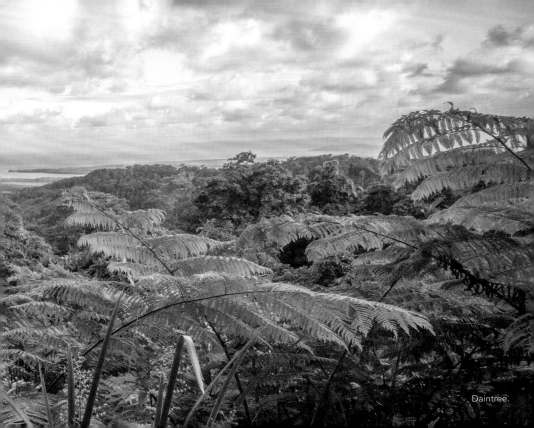
Daintree.

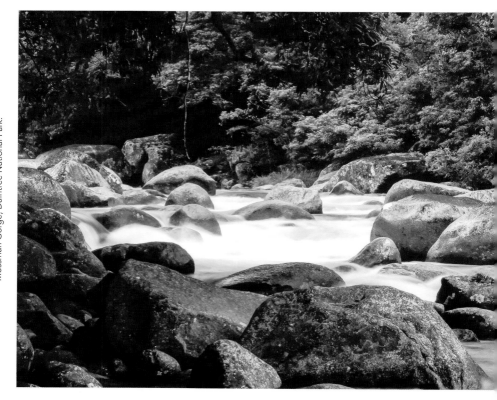

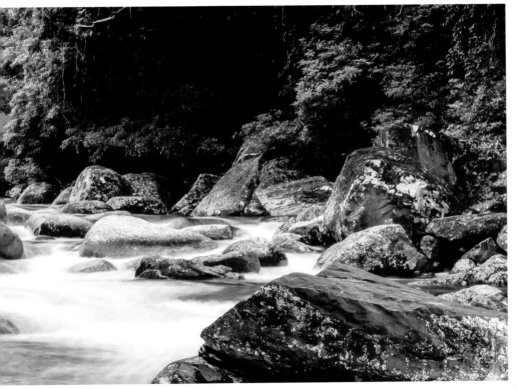

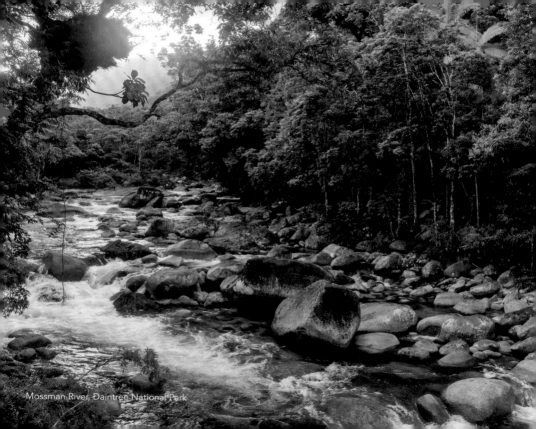
Mossman River, Daintree National Park

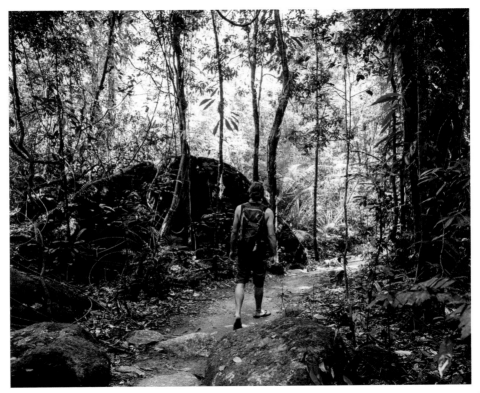

Overlooking Kulki Beach, Cape Tribulation, Daintree National Park.

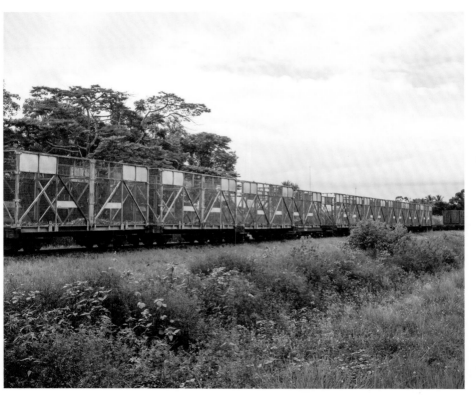

Sugar cane truck, Daintree.

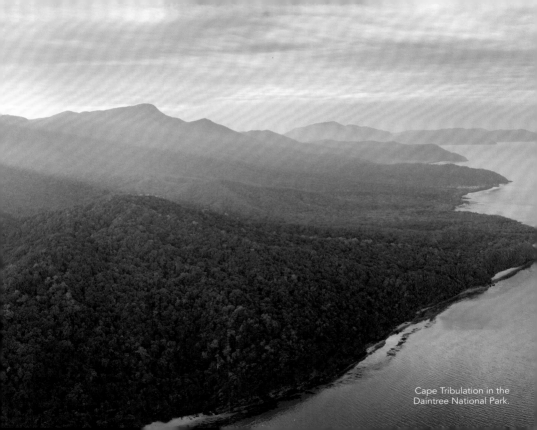

Cape Tribulation in the
Daintree National Park.

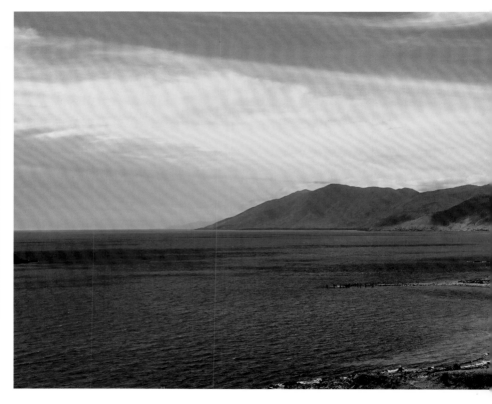

Archer Point Conservation Park, 20 km south of Cooktown.

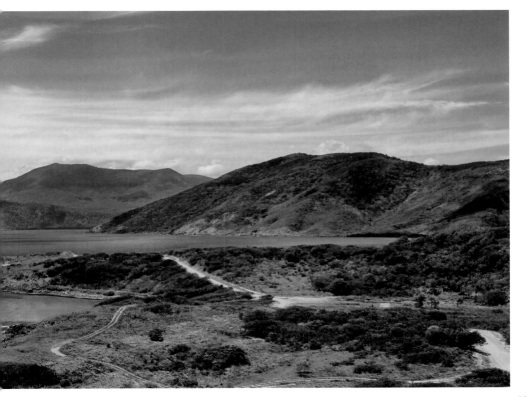

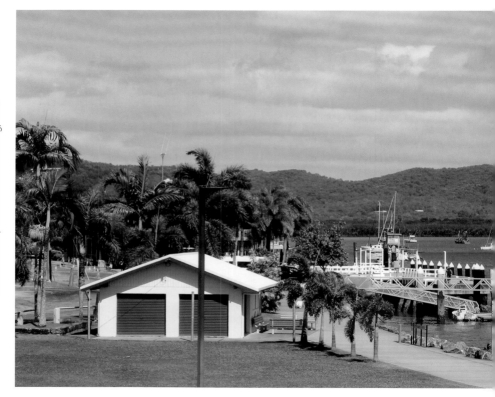

Endeavour River, the site of Cook's landing, 1770.

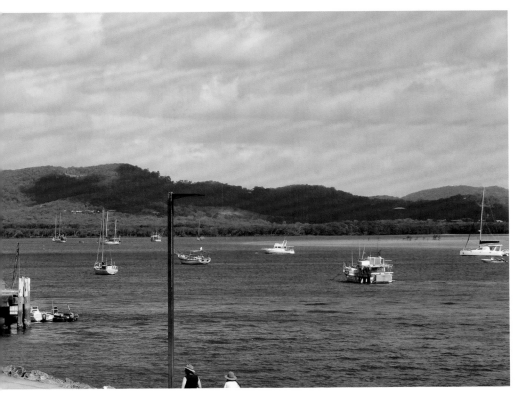

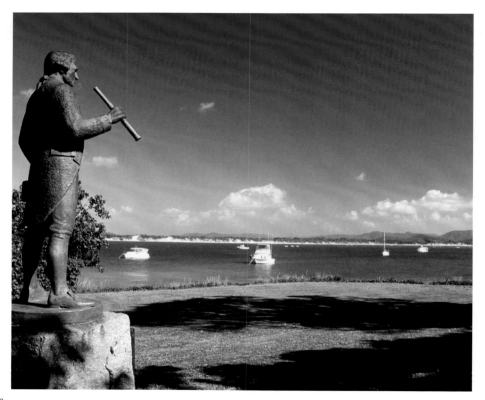

Cooktown foreshore commemorates the 1770 visit by Captain Cook.

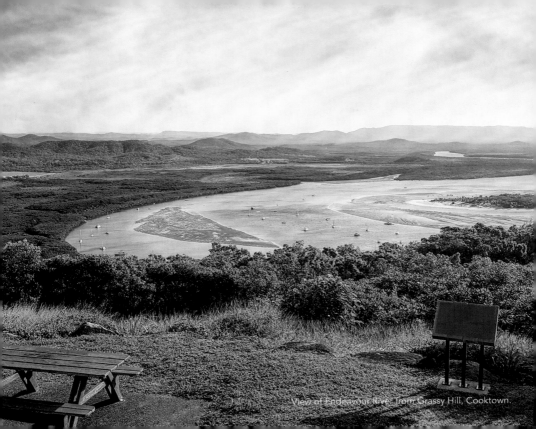

View of Endeavour River from Grassy Hill, Cooktown.

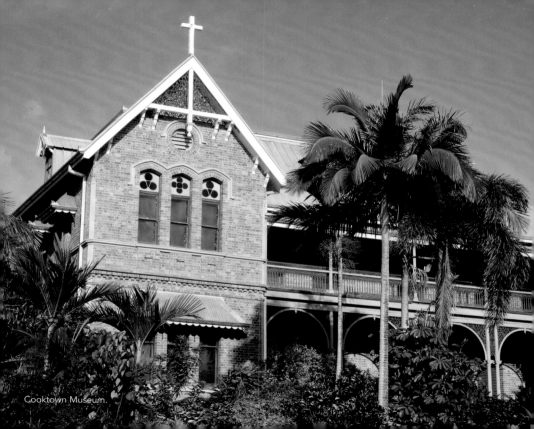

Cooktown Museum.

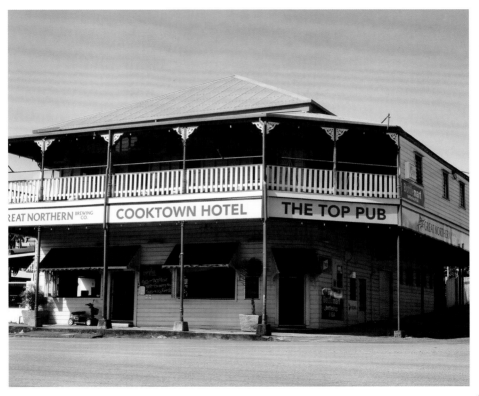

Cooktown hotel on Cooktown main street

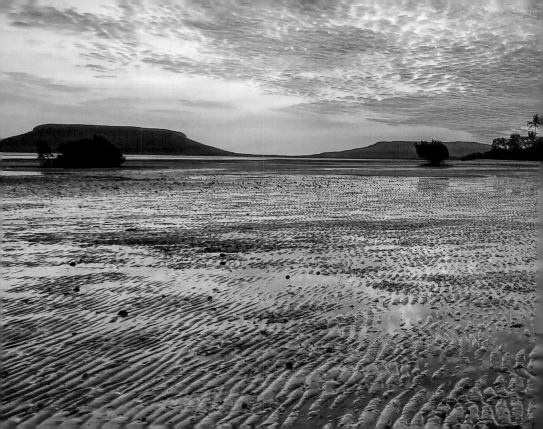

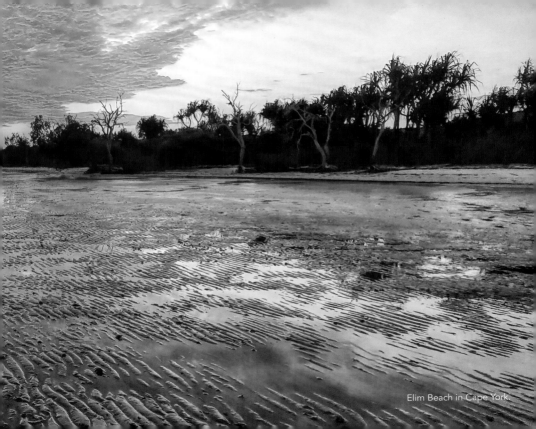

Elim Beach in Cape York.

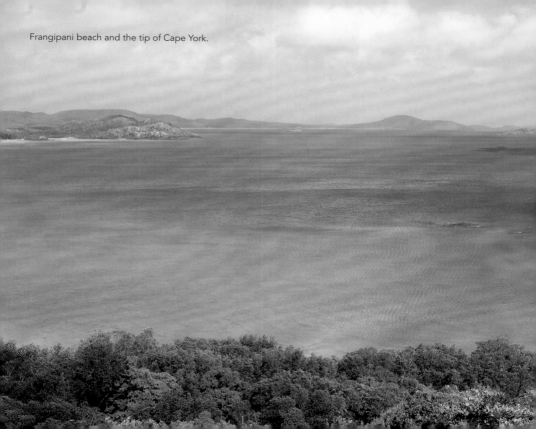
Frangipani beach and the tip of Cape York.

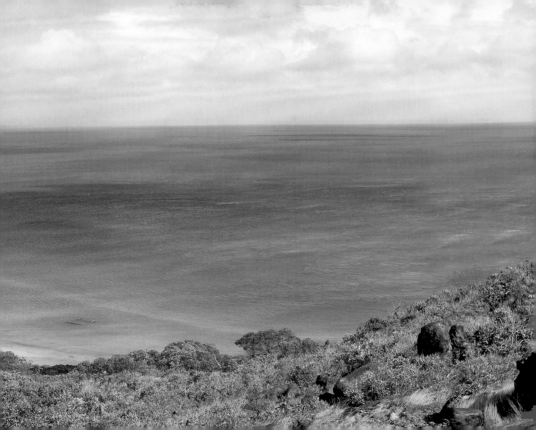

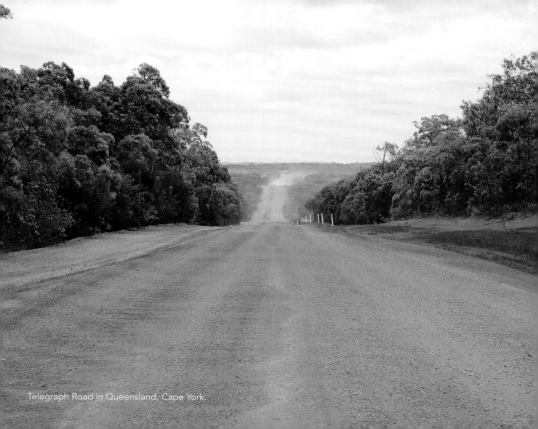
Telegraph Road in Queensland, Cape York.

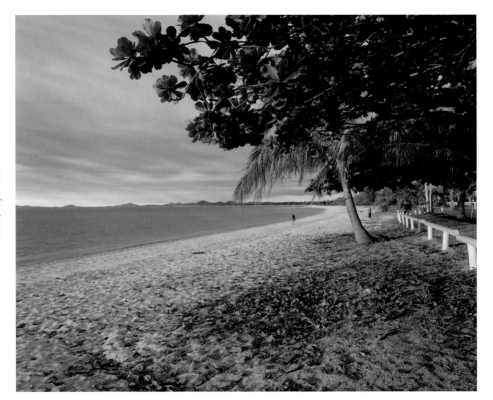

Seisia, Cape York.

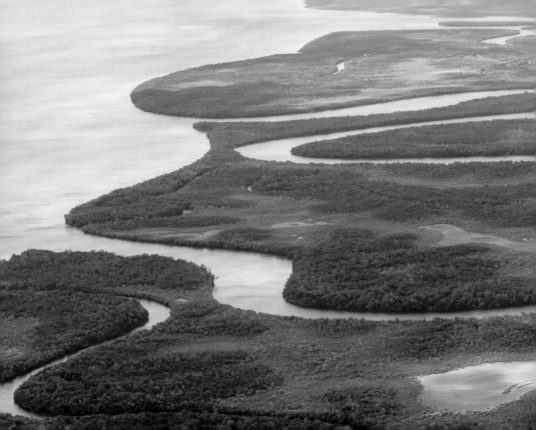

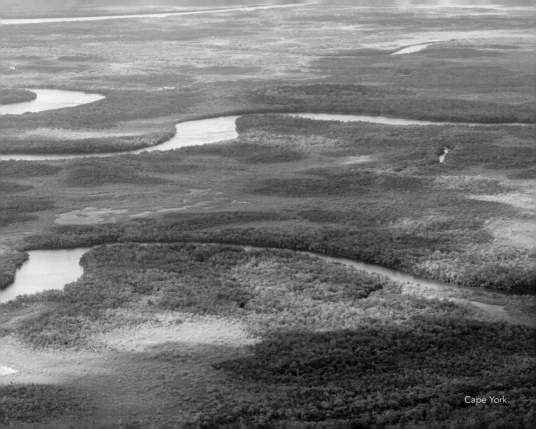

Cape York.

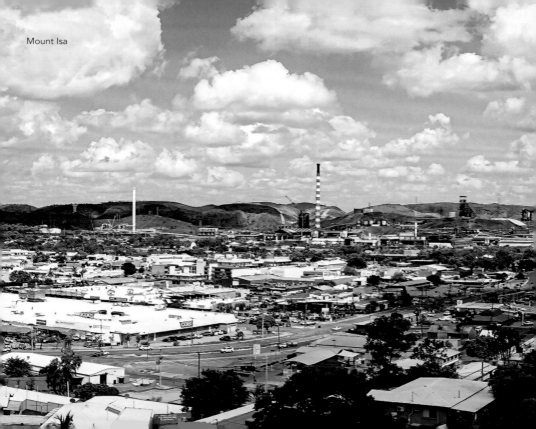
Mount Isa

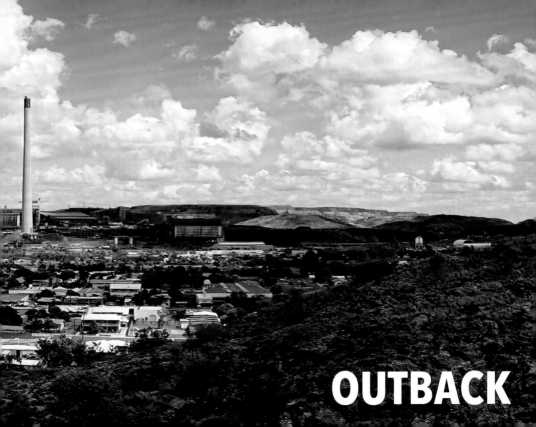

OUTBACK

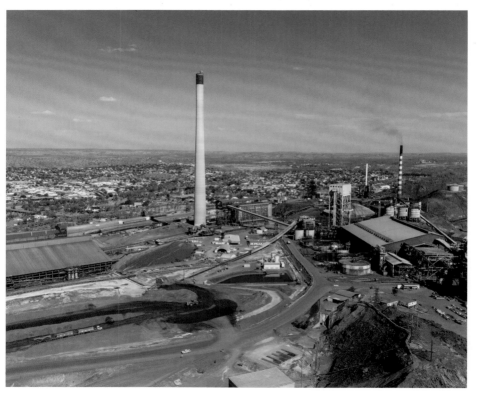

Glencore's Mount Isa mine is set to close in 2025.

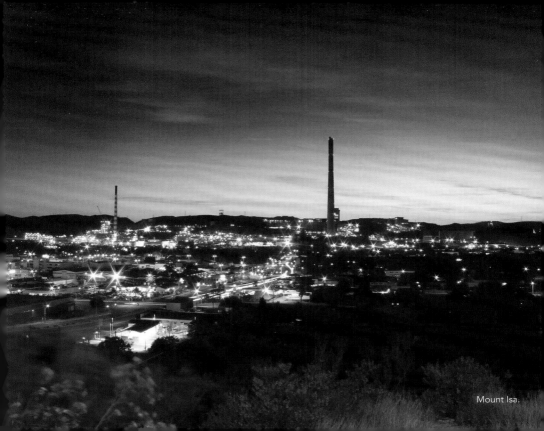

Mount Isa.

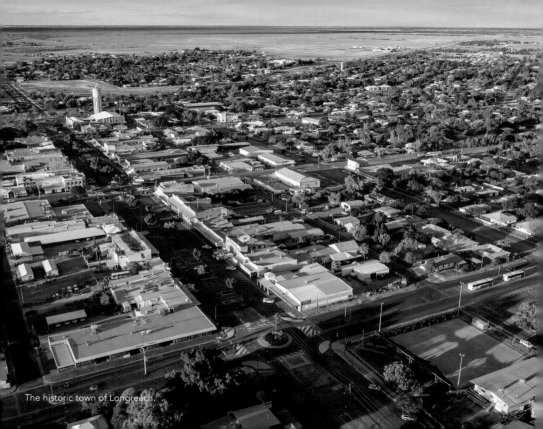

The historic town of Longreach.

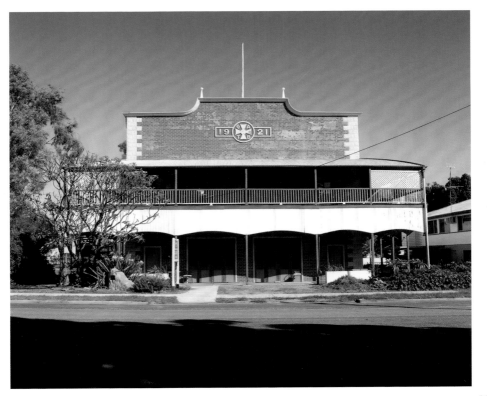

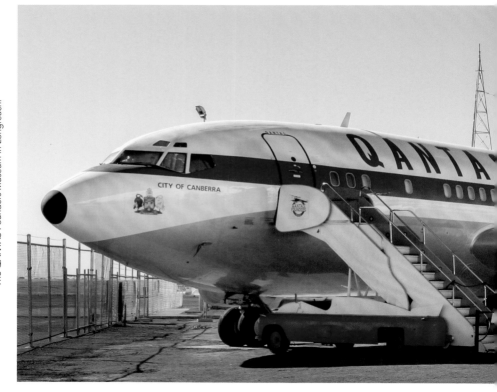

The QANTAS Founders Museum in Longreach.

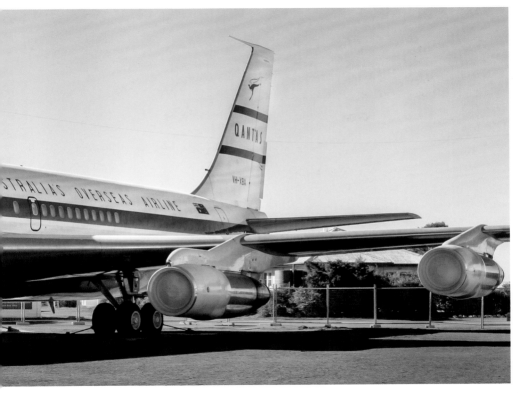

331

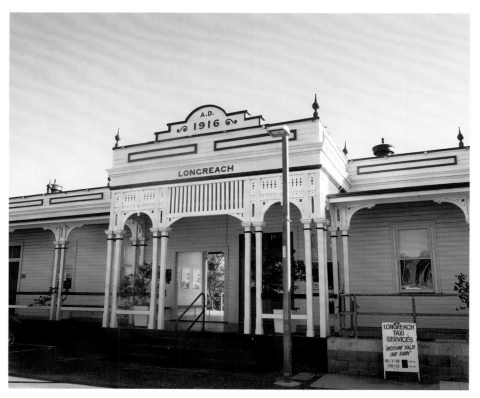

Historic Longreach Railway Station.

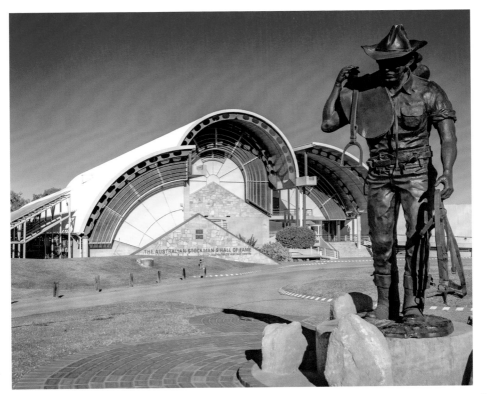

Australian Stockman's Hall of Fame and Outback Heritage Centre, Longreach.

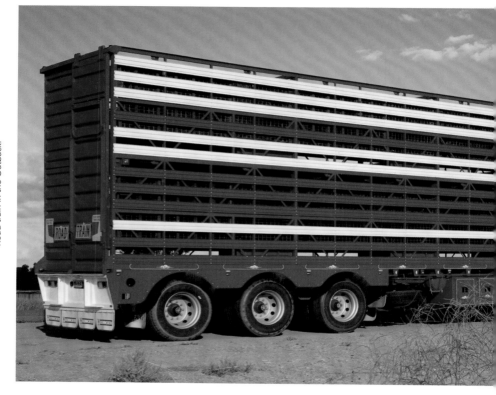

Road train in the Outback.

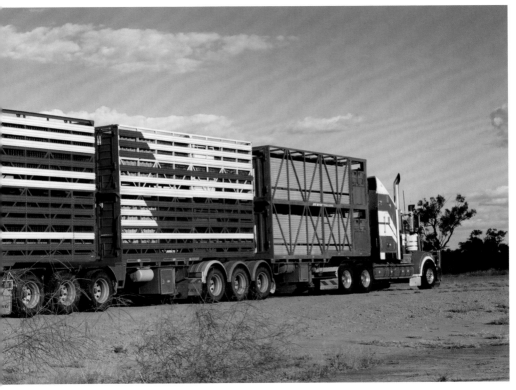

Emerald Historic Railway Station.

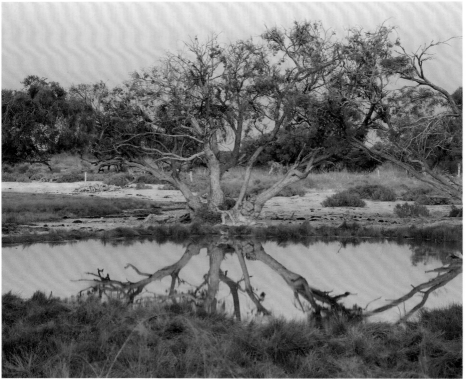

The Big Rig oil and gas exploration centre, Roma.

Bjelke-Petersen Dam, Lake Barambah, Kingaroy.

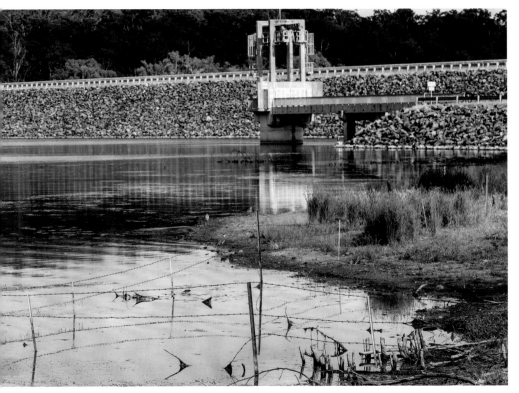

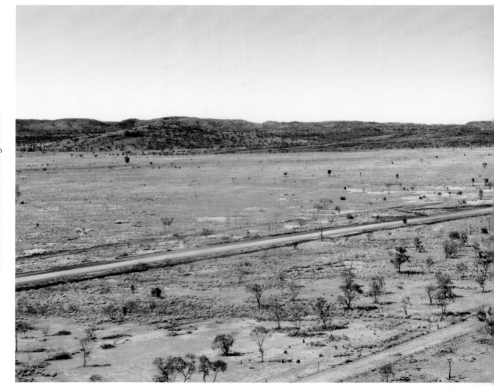

The barren outback at Riversleigh Downs.

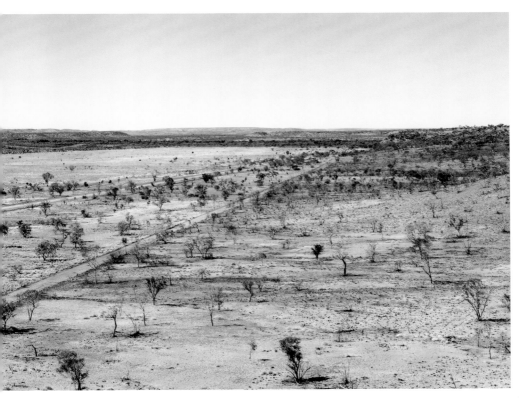

Kingaroy Peanut Silos

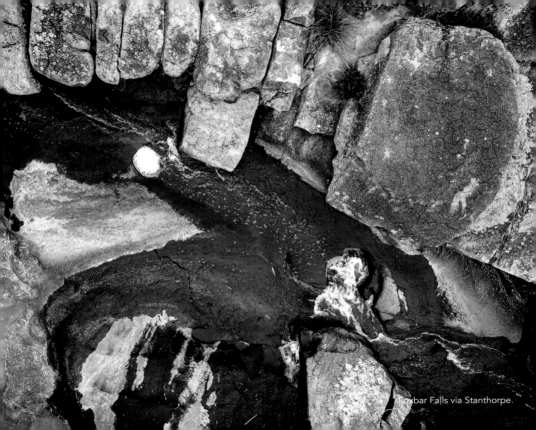
Foxbar Falls via Stanthorpe.

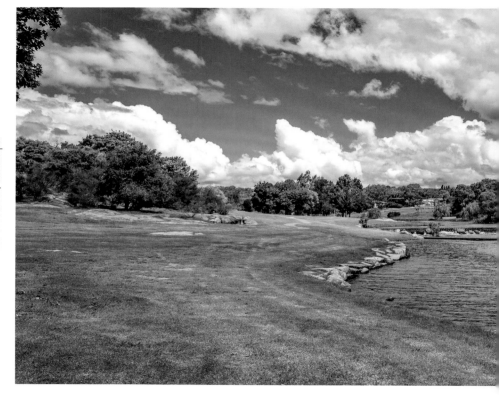

Quart Pot Creek, Stanthorpe.

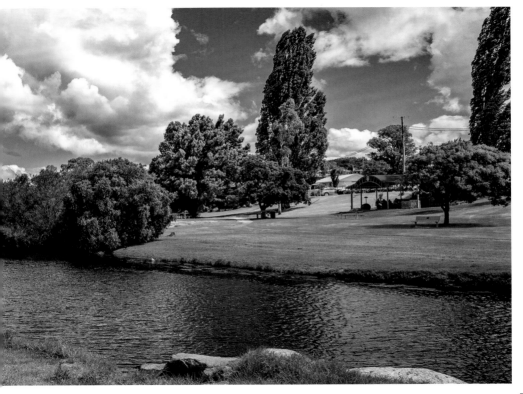

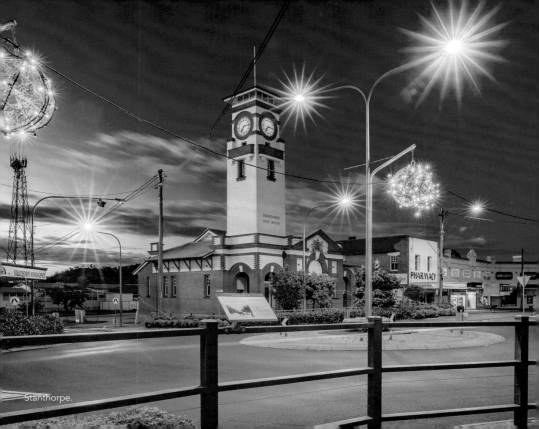

Stanthorpe.

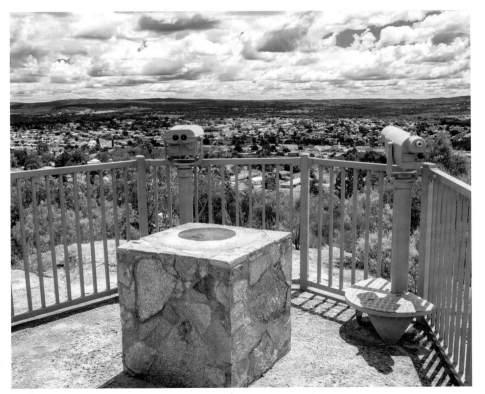

View from Mount Marlay lookout in Stanthorpe.

Stanthorpe.

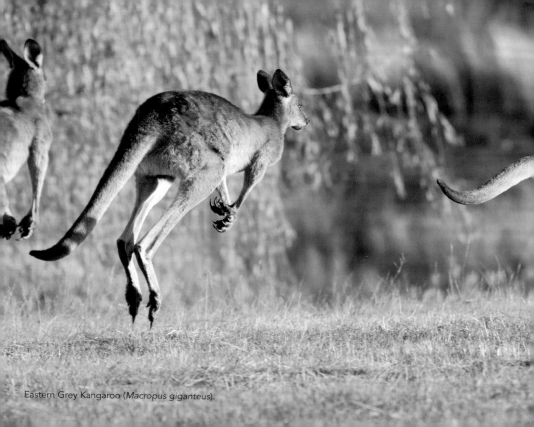

Eastern Grey Kangaroo (*Macropus giganteus*).

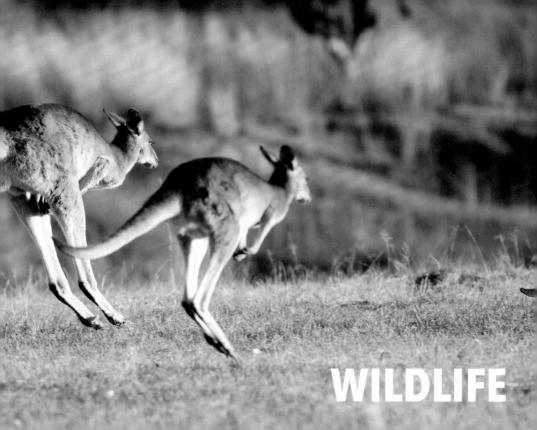

**WILDLIFE**

Brush-tailed rock-wallaby (*Petrogale penicillata*) at Currumbin Wildlife Sanctuary, Gold Coast.

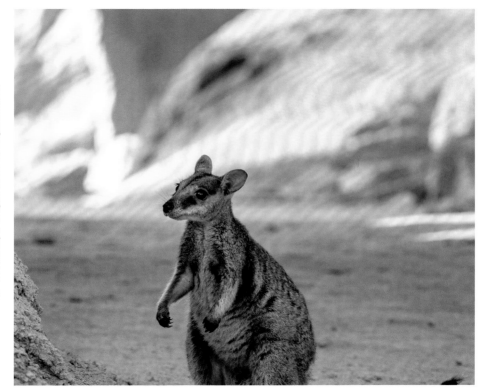

Allied Rock-wallaby (*Petrogale assimilis*), Magnetic Island.

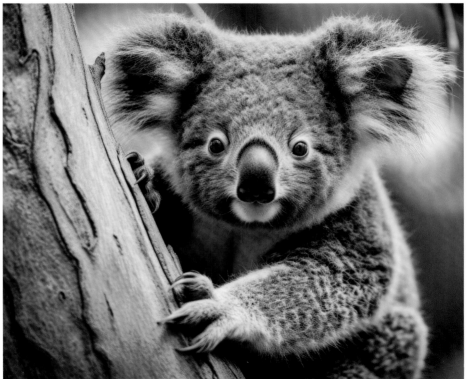

Koala (*Phascolarctos cinereus*) at Lone Pine Koala Sanctuary.

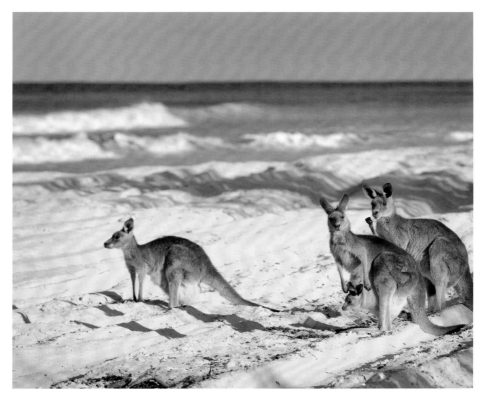

Red Kangaroos (*Osphranter rufus*) on the beach in Bribie Island.

Saltwater crocodile, Daintree River.

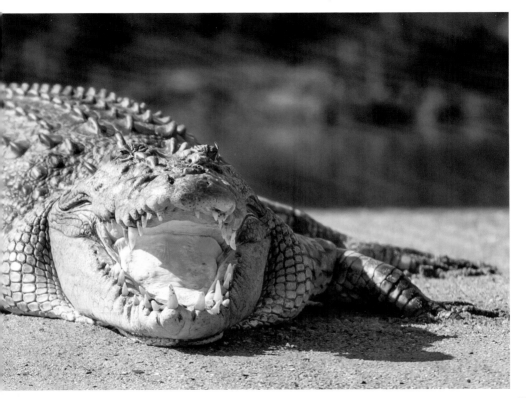

Laughing Kookaburra (*Dacelo novaeguineae*), Atherton Tablelands.

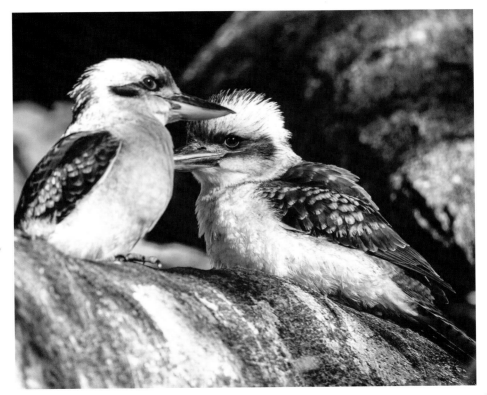

Blue-winged Kookaburras (*Dacelo leachii*).

Galah (*Eolophus roseicapilla*) or Pink and Grey Cockatoo.

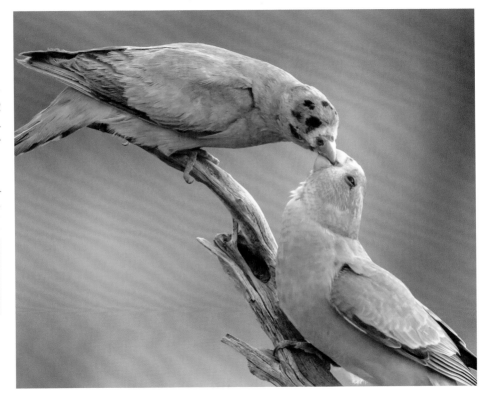

Golden-shouldered Parrot (*Psephotellus chrysopterygius*).

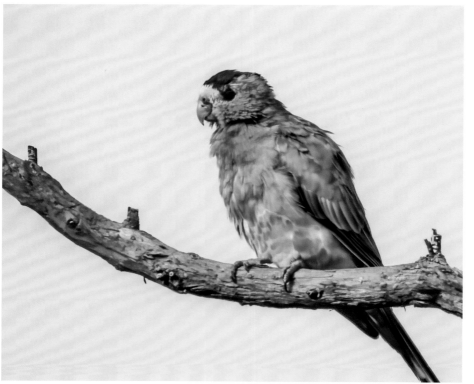

Golden-shouldered Parrot (*Psephotellus chrysopterygius*).

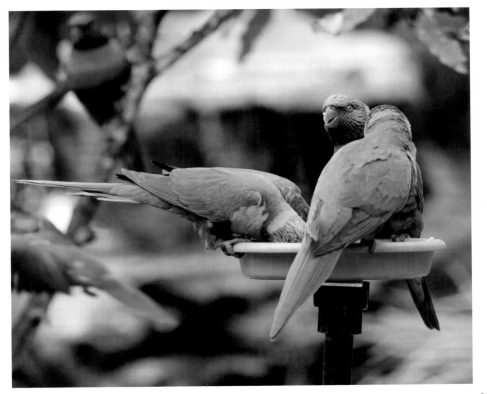

Rainbow Lorikeets eating in Lone Pine Koala Sanctuary.

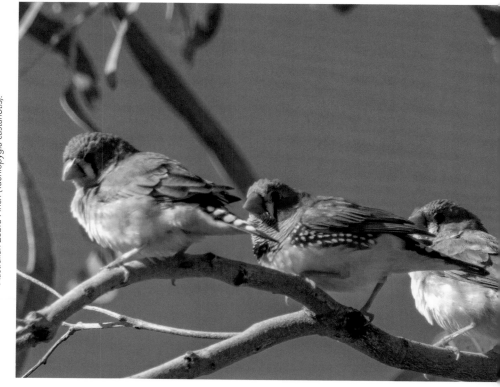

Australian Zebra Finch (*Taeniopygia castanotis*).

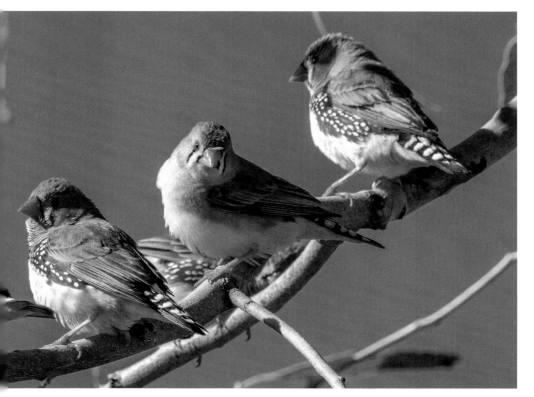

Red-Tailed Black Cockatoos (*Calyptorhynchus banksii*).

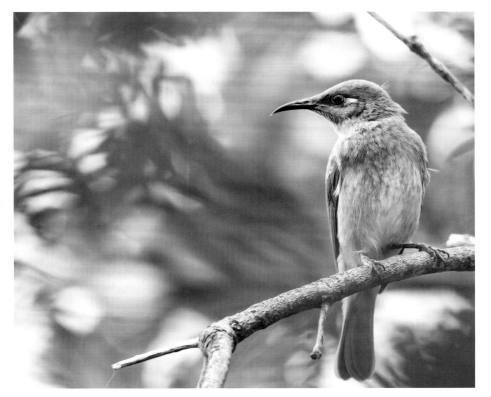

Brown Honeyeater (*Lichmera indistincta*).

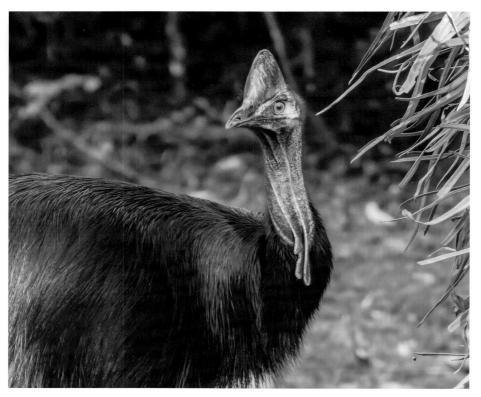

Southern Cassowary (*Casuarius casuarius*).

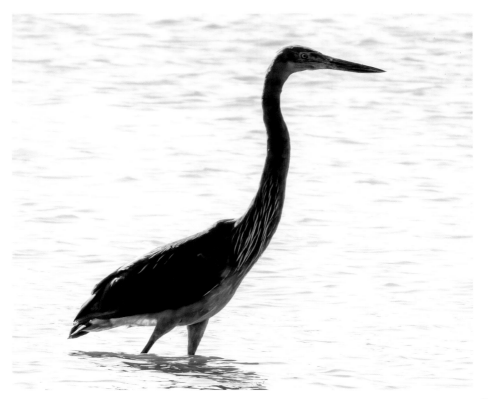

Great-billed Heron (*Ardea sumatrana*).

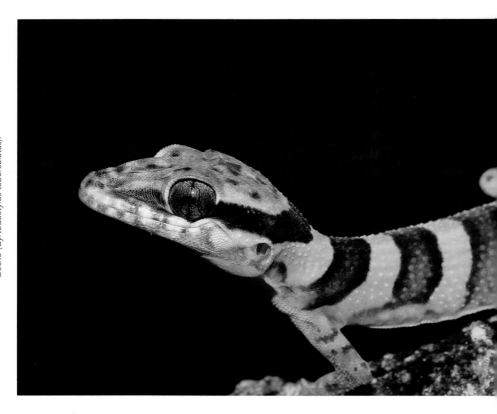

Gecko (*Cyrtodactylus tuberculatus*).

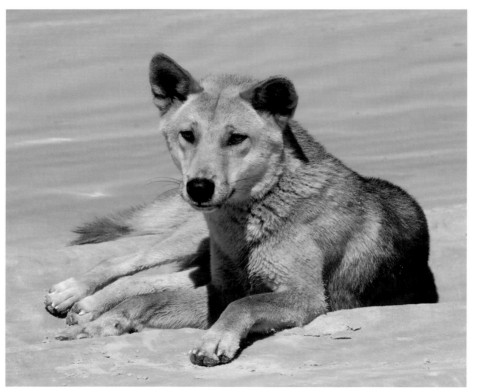

Dingo (*Canis familiaris*) relaxing on the beach at K'gari (formerly Fraser Island).

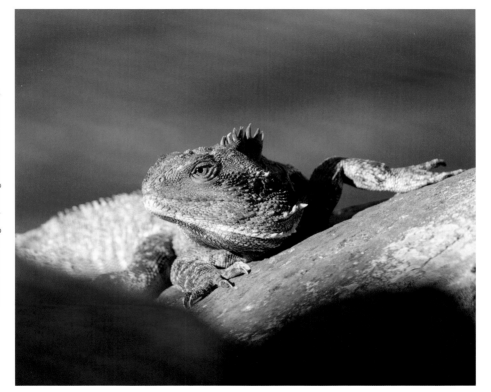

Eastern Water Dragon (*Intellagama lesueurii lesueurii*).

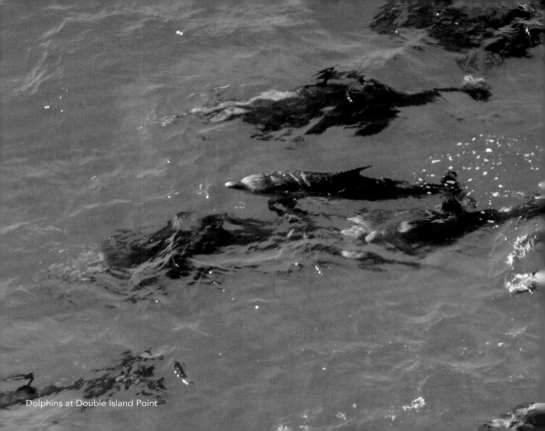

Dolphins at Double Island Point

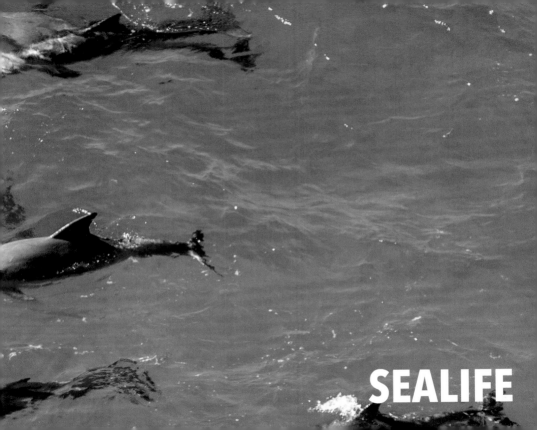

SEALIFE

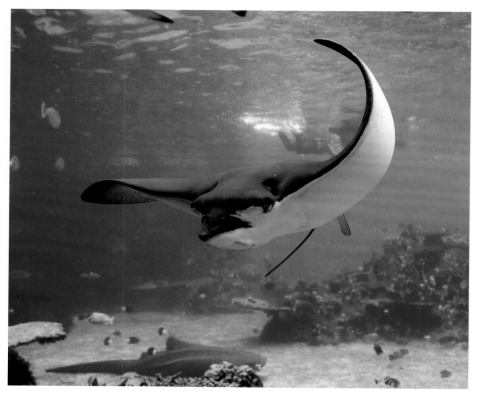

Bull Ray (Aetomylaeus bovinus).

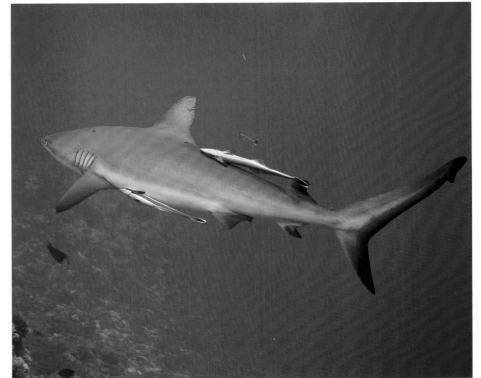

Grey reef sharks (*Carcharhinus amblyrhynchos*), Osprey reef

379

Potato Cod in the reef.

Potato Cod (*Epinephelus tukula*), Great Barrier Reef.

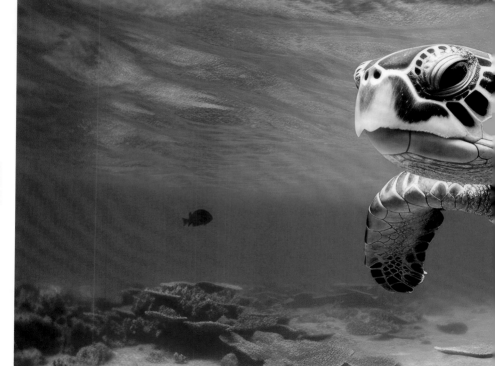

Sea Turtle.

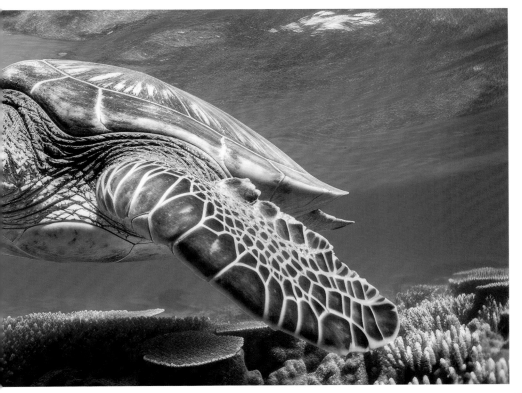

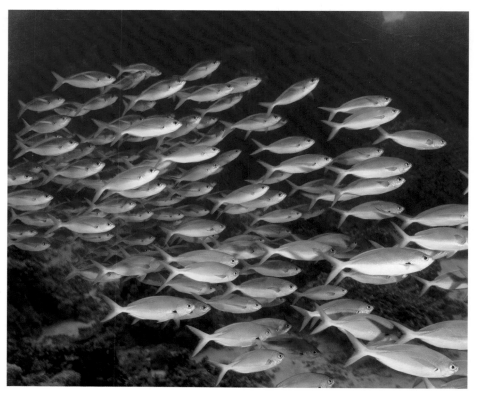

Blue and gold fusiliers.

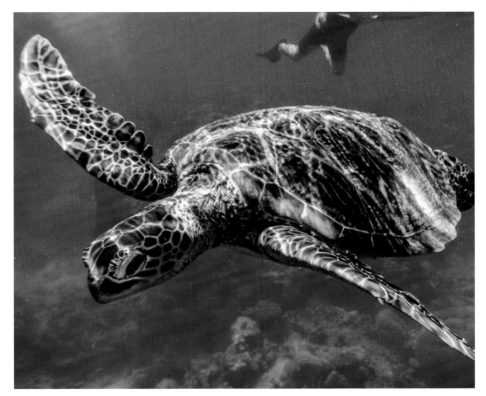

Marine Turtle, Great Barrier Reef.

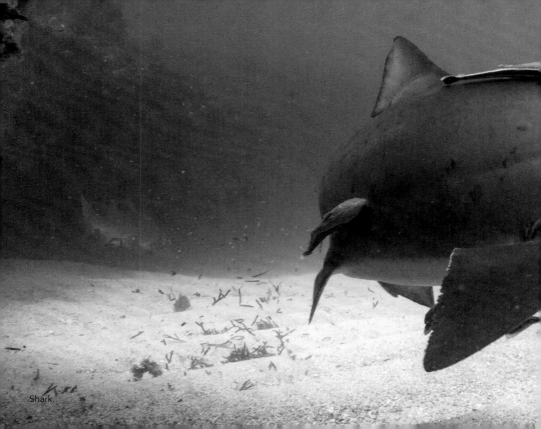

Shark.

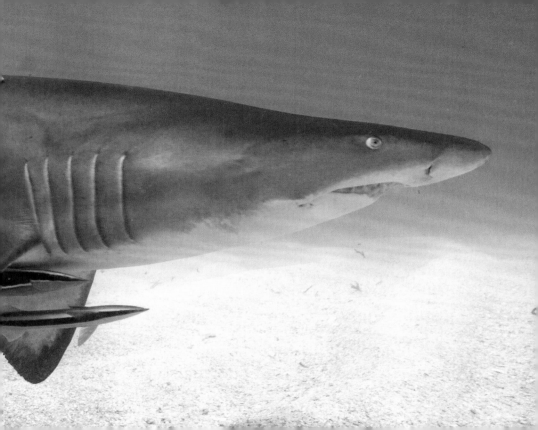

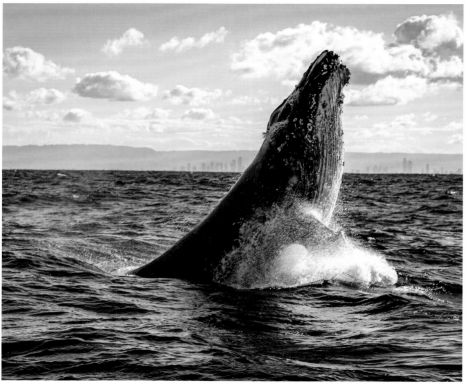

Humpback Whale (*Megaptera novaeangliae*).

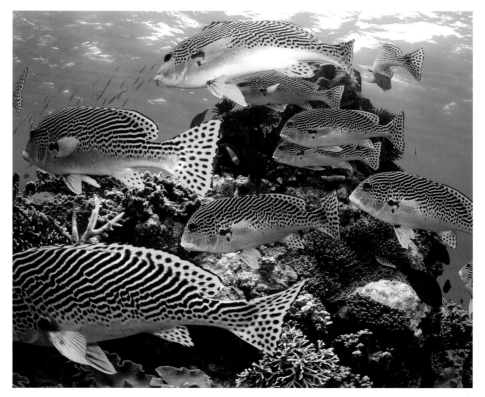

Yellow-banded sweetlips (*Plectorhinchus lineatus*).

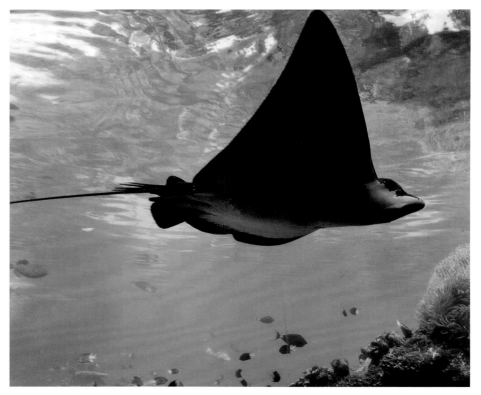

Marine Stingers.

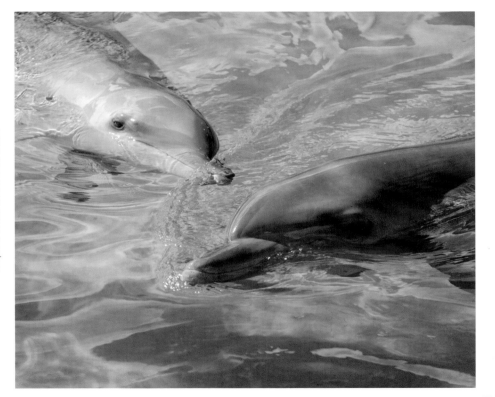

Dolphins at Sea World, Gold Coast.

Gum Tree (Eucalyptus praya).

NATURE

Black Bean Tree (*Castanospermum australe*)

Frangipani flower.

Jacaranda trees (*Jacaranda mimosifolia*).

Lemon Myrtle (*Backhousia citriodora*).

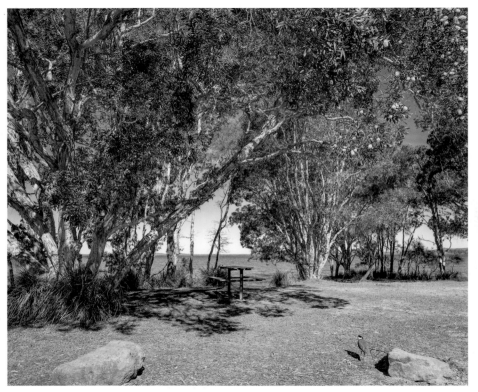

Melaleuca paperbark trees.

Red flowers of the Broad-leaved Paperbark (*Melaleuca viridiflora*, family Myrtaceae).

First published in 2024 by New Holland Publishers
Sydney

Level 1, 178 Fox Valley Road, Wahroonga, NSW 2076, Australia

newhollandpublishers.com

A record of this book is held at the National Library of Australia.

ISBN 9781760796709

Managing Director: Fiona Schultz
Designer: Andrew Davies
Production Director: Arlene Gippert
Printed in China

10 9 8 7 6 5 4 3 2 1

Keep up with New Holland Publishers:

 NewHollandPublishers

 @newhollandpublishers